THE MUSES GO TO SCHOOL

THE MUSES GO TO SCHOOL

*Inspiring Stories About the
Importance of Arts in Education*

Edited by HERBERT KOHL
and TOM OPPENHEIM

The Stella Adler Studio of Acting wishes to extend its gratitude and
appreciation to Thomas Oppenheim for his contributions to this book.

Requests for permission to reproduce selections from this book should be mailed to:
Permissions Department, The New Press, 38 Greene Street, New York, NY 10013.

Published in the United States by The New Press, New York, 2012
Distributed by Perseus Distribution

LIBRARY OF CONGRESS CATALOGING-IN-PUBLICATION DATA
The muses go to school : inspiring stories about the importance of arts
in education/ edited by Herbert Kohl and Thomas Oppenheim.
p. cm.
ISBN 978-1-59558-539-4 (hc)
1. Arts—Study and teaching. 2. Education—Aims and
objectives. I. Kohl, Herbert R. II. Oppenheim, Tom.
NX280.M87 2012
700.71—dc23 2011042803

The New Press was established in 1990 as a not-for-profit alternative to the
large, commercial publishing houses currently dominating the book publishing
industry. The New Press operates in the public interest rather than for private
gain, and is committed to publishing, in innovative ways, works of educational,
cultural, and community value that are often deemed insufficiently profitable.

www.thenewpress.com

Composition by dix!
This book was set in Minion Pro

Printed in the United States of America

2 4 6 8 10 9 7 5 3 1

CONTENTS

THE MUSES GO TO SCHOOL

Preface: The Necessity of Art in Public Education

HERBERT KOHL

The world we live in shifts more quickly than the continental plates beneath us and we feel the effects more directly. Young people sense these shifts and have new ways, through social media, of communicating their anxieties, hopes, and enthusiasms regularly with friends and with people beyond their neighborhoods, often beyond national boundaries. These youngsters make films, take pictures, send text messages, communicate across the globe with Web sites and blogs of their choice, and have their own Facebook and YouTube identities. They also love to dance and sing and act with their friends. They do not separate the electronic from the physical, the virtual from the actual worlds they live in. There is a marriage of performance and electronic connection that young people engage in throughout the world at the same time that their schools close down the arts; force rigid curricula that pass for literacy and math programs; promise jobs that don't exist; and turn the magic of learning about the wonders of the world, nature, and other peoples and cultures into rigid, tortuous sitting in claustrophobic rooms and constant testing

that has little or no meaning for intellectual, personal, and social development.

Some politicians, publishers, academic statisticians, and educational entrepreneurs may profit from this cynical strategy of conformity and management of learning. In fact, in order to keep the testing-industrial complex in power, the main weapon is fear—fear on the part of the parents that their children won't get into a good college or get a good job, and fear on the part of the kids of parental and social disapproval.

Social media and participation in the arts are redeeming for the young. They give children (and adults) power, joy, challenge, a sense of their own personal capacity to do wonderful things. And they provide common bonds with other people the same age. Too many adults worry about the distraction of young minds from the focused activity of conforming to tests and scripted curriculum, but even when the young seem to comply, they don't. They live double lives: classroom lives and social and artistic lives. The goal of introducing the arts as central to schooling is to join these two aspects of living and learning into a harmonious if sometimes fractious whole.

When Bob Marley died in 1981, his death was devastating to my children, who were in high school at the time. My son, Josh, was in a reggae band and played Marley covers beautifully. My middle child, Erica, listened to his music as did my oldest, Tonia. At that time Tonia was developing her hatred of the local high school. It was not because she was a failure. On the contrary, she was a straight-A student. But she was an outspoken feminist and antiwar activist who was fearless when it came to raising sensitive issues in class.

Her teachers did not appreciate her outspokenness and tried feebly to appeal to my wife Judy and me to rein her in. We felt that if her questions were intelligent and provocative, we would be 100 percent behind her, which we were. But we also realized that she was very unhappy in school, and it took a toll on her feelings about herself. Was she a problem or was the school a problem?

She faced the same issue faced by other students who deviate from often foolish norms that are imposed on high school students. Our society has experienced extreme versions of this rejection and alienation, such as, for example, the events at Columbine. Tonia was not an extremist, however; she was an artist, for which, as her father, I am grateful. The arts become, for many young people, a way to express ideas, feelings, understanding, and concerns that could otherwise end up in inarticulate acts of thoughtless and usually self-destructive violence.

I didn't know much about the depth of Tonia's feelings about Bob Marley. One day she called me into her bedroom. She wanted to show me something. She went to the closet and took out a carefully wrapped package, about two feet by three feet, untied the string, and took out the most beautiful and passionate paintings of Marley from the time he was about three or four through his music career to his last days when, wasted by cancer, he died at the age of thirty-six.

I was moved by the paintings, but wondered how she had done them. We had never known her to be a painter, she had never taken an art class, or spoken about this passion. She had had no opportunity to learn about painting in school. It was a private and wonderful obsession.

A year and a half later, just before she was to graduate from high school, she swore to us that she would never go to school again. She felt that she had no opportunity to express and develop her skills or to have her ideas heard in the context of school. It is perilous at the age of seventeen to act on negativity rather than move toward something positive, no matter how irregular the path might be. So we said, "What about art school?" and her answer was, "Depends."

We spent the next year in London because of my work, and Tonia did go to two art schools—one modern and wild, the other traditional. The following year she went to the Rhode Island School of Design, where she made lifelong friends and honed her skills as an artist. But she is not a painter now. Given her education and her engagement with the arts, and through her parents' association with progressive education ideas, she has become a game designer working in the computer world. A feminist still, she and a friend founded a company that develops virtual reality platforms and programs for games designed primarily for young women.

What is important in this context is that studying art is empowering whether one becomes an artist or not. It develops imaginative problem-solving skills, boldness, an understanding of the planning and execution of creative work, a spirit of independence and entrepreneurship, experience with disciplined and hard work, and, finally, the deep satisfaction of being able to use your mind and skills to produce results you honor and are willing to risk putting out in public.

Entrepreneurship and the arts often go hand in hand and this is

not adequately appreciated in our society, even when people who take risks and put themselves out there become successful. When there are calls for the development of programs in the school curriculum that foster creativity, the arts would make ideal courses for providing skills to young people that will enable them to develop creative solutions to seemingly intractable problems.

The arts are not just for people who become artists. They are integral to the development of self-confidence, character, creativity, a capacity to deal with the tragicomic nature of life, and, fundamentally, the capacity to reach deep into yourself and draw upon your own inner strengths to solve problems in difficult times. Listening to music while thinking through a problem, dancing to become in touch with your body and your partner, painting and drawing and sketching out your state of mind and your finances, designing your new home, budgeting your spending—all of this depends upon creative imagination. On an everyday level, the more resources you have from a complex and interesting education in the arts, the stronger and more effective you are likely to be.

Young people have a hunger for creative activity. This ranges from performing music to computer gaming, from athletics to acting, from basketball to ballet. This hunger derives from hope, which comes in many forms—hope to be a star, hope to get away from an impossible situation, hope to create something new and beautiful, hope to meet new friends and confront challenges that tease and please you, or simply hope that you will find a safe place to learn and grow.

• • •

In this book Rosie Perez and Bill T. Jones talk about their own dis-coveries of their vocations and the way the arts focused their lives. Phylicia Rashad talks about how the discipline of theater was central to her growth and education. Moisés Kaufman talks about his en-gagement, through theater, with the community in Laramie, Wyo-ming, over the senseless and cruel death of a young gay man, and Philip Seymour Hoffman talks about his vision of a holistic educa-tion for his own children and the role the arts might play in their de-velopment. Whoopi Goldberg speaks about the joy the arts provided her as she grew up in New York. David Amram, in his eccentric way, talks about how the arts can be an antidote to confused diagnoses of hyperactivity. Frances Lucerna talks about how dance and partici-pation in the thoughtful development of arts-related activities can help young women come to terms with their feminine identity. And film producer Mike Medavoy discusses how the arts facilitate emo-tional growth and provide a window to understanding the human experience. Taken together, these conversations explore the lives of people who have achieved artistic excellence and who have a sense of the importance of the arts in education.

My friend's daughter, when she was in junior and senior high school, wanted to be a famous blues singer—not just *a* blues singer, but a famous one. Alicia was a brilliant student, she could argue a streak, and could reason anyone into submission. But singing and perform-ing were essential to her social and personal life.

When she was in college and still struggling to be a singer, we had lunch. She admitted to me that she was becoming insecure and depressed about her ambitions. And then she gave me a hint about how to help her. She said, "I just want to be around music and the music business." It emerged that she would be delighted to be a lawyer working in the music industry, which is what she does now.

Lenny was outrageous, brilliant, and hilarious. He also didn't understand the social propriety of keeping your mouth shut while teachers or friends were talking. In other words, sometimes he was a delight to be around, and at other moments, a chore. He was and still is a large presence. He also wrote well and was fearless, both socially and electronically. For all the brilliance and bluster, he felt lonely. He was scared and had no idea what he could do after high school. Where would all this energy and intelligence go? He lucked into theater. He did amazing stand-up comedy, the very thing that his teachers hated. And it connected him, made him part of a community of peers engaged in the arts despite the school's lack of opportunity.

These are small examples of the power of the arts—to connect the disconnected, to appreciate and alleviate pain, and to hone the rebel and the wild imagination so that they become of benefit to the person and society. Lenny did not ultimately become a professional actor or stand-up comedian, but he is a prominent journalist and blogger who specializes in reporting on the Detroit automotive industry for a major paper.

It is essential to understand that the arts in education are crucial for preparation for adult life. The arts play a powerful role in shaping

young lives. And the struggle for some to achieve academic excellence and a positive, imaginative sense of one's place in the world without the benefit of the arts is a form of impoverishment.

The arts do not play a single role in the development of intelligence, sensitivity, social responsibility, and personal awareness. At a minimum, the arts contribute to young people's development by providing:

- focused discipline and self-discipline through involvement with personal and group activities with high standards taught by devoted teachers
- integrated personal and academic development and substantial motivation for becoming literate
- paths to self-discovery, inspiration, and spirituality
- vehicles for dreaming of possible social transformation and participation in the transformation of dreams into images and actions
- healing, joy, and sustenance in both hard and good times
- entertainment and companionship, as evidenced by young people who say "This is my music" without having created it, but by being thoroughly engaged in it on a complex personal level
- business training—as a motivation to learn how to run a business, make money, become self-supporting, or become part of the large entertainment industry
- social engagement, and the courage to reach out with one's own style and dreams

- physical personal expression, discovering what you are thinking, and sharing with the young your visions of the world in tiny and larger ways
- cultural affirmation, expressing or revitalizing personal and community identity and having a way to share it
- expression of social, racial, and gender stigma and leading the way to exposing it and to living beyond stigma
- connecting with the past and history, and honoring the traditions that have contributed to our common development
- understanding style and propaganda, as a way of encouraging young people to create images that transform people's thinking and sensibilities
- understanding and transforming technology on both a technical and performance level
- acting as antidotes to hyperactivity and Attention Deficit Disorder, providing alternative ways of learning
- serving as an entrée to Children's Rights and Social Justice issues, providing opportunities to be creative to all children.

A NOTE ON THE MAKING OF THIS BOOK

In coming up with the idea for this book, my intention was to put to rest, once and for all, the bizarre idea that the arts—aspects of learning that are central to the development of the soul, intelligence, and the community—are merely frills or embellishments to a meaningful education. I would like to thank sincerely Tom Oppenheim of the Stella Adler Studio of Acting for his invaluable contributions to

the creation of this book. It would not have been possible without him. I would also like to thank Leonard Lopate, who moderated the original panel discussion that inspired this book. I am truly grateful to all of the artists who have generously shared their stories and perspectives in these pages; it was an incredible experience to work with each of them. After interviewing the artists, I then approached the esteemed educators who graciously participated in this project and whose comments are included in this work. My goal with these creative pairings (a format from which I strayed only in the last chapter to include two marvelous educators, Maxine Greene and Shirley Brice Heath) was to craft a book whose unique structure would do justice to the unusual complexity of the subject it treats. Last but not least, I want to thank my editor, Diane Wachtell, and her assistant editor, Tara Grove, for all of the help, patience, and astute editing they provided in the making of this book. In particular, I want to thank Diane for holding my hand throughout the course of this complex project.

Introduction:
The Arts and Social Justice

TOM OPPENHEIM

I have long held two convictions: that the arts are essential for human life and growth, and that the arts are for everybody. My efforts as the artistic director of the Stella Adler Studio of Acting to uphold and extend a specific theatrical tradition, one that is both artistically potent and socially engaged, have made me aware that the arts have been virtually eliminated from public education throughout the United States, particularly in economically challenged neighborhoods. This is a terrible result of an even more threatening phenomenon: the separation of the arts, in general, from the realm of serious educational consideration and practice. There is a growing sense in the United States that the arts represent one of life's frills rather than an essential human activity and achievement, and that, therefore, they are dispensable in public education.

The purpose of art education is not the mass production of artists. Rather, it is the welcoming of young people into a language and dialogue that is essential to all humanity and that is timeless. We who are devoted to bringing the arts to all our children, regardless of

economic status, seek to facilitate voice and vision and thereby usher young people into the fullness of their humanity. This is particularly important in low-income areas where opportunity is often meager and a fertile imagination might well be a matter of life and death.

At the Stella Adler Studio of Acting we experience the power of the arts in education daily; indeed, it is woven right into our history. From the immigrant roots of Jacob Adler and the Yiddish Theater, to the socially engaged and artistically audacious fervor of Harold Clurman and the Group Theater, to the impassioned, imagination-based approach to acting of Stella Adler, the tradition from which we come attests to the essentiality of the arts to human growth and to the power of the arts to uplift, edify, and, in the most profound sense of the words, educate and civilize humanity.

As Stella's grandson, I have been greatly influenced by this history and the spirit of this tradition. From the start I have understood the social function of art and the power of the arts—particularly, in my case, theater—to effect change both personally and socially. From a very young age I experienced both my grandmother's concern for and involvement with the theater as a vehicle for change as well as the involvement of many of Stella's most gifted students in social struggles—for example, the civil rights movement of the 1960s. I was nine years old in 1968 when Martin Luther King Jr. was assassinated. I remember the event because my diet of TV cartoons was interrupted by broadcasts of the assassination and the terrible consequences of the riots that took place in its wake. I also was exposed for the first time to the magnificence of King's oratory, his moral grandeur, the fury of his love, and his willingness to die for

the cause of justice. I fell in love with the cause and collected money from family friends for the Southern Christian Leadership Conference, twenty-four dollars in all. It took me months and seemed like a great deal of money then.

This history provided me with a vision for the Stella Adler Outreach Division. Its educational mission is twofold: to bring free actor training to low-income inner-city youth while providing our full-time students with a model of social engagement. Having grown up around actor training and having trained as an actor myself, I was aware of the incredible power of that training to open up the body, mind, and spirit; to fuse discipline and fun through play; to widen radically one's scope of understanding.

Today, through the Stella Adler Outreach Division, we encounter young people whose families live on or below the poverty line. Often these young people have never visited a museum, heard a play, or read a poem. Their only role models are commercial constructs produced to boost ticket or record sales. Rarely, if ever, do they receive, in their world, an invitation to explore their own voices, their soul power, their capacity and right to see and be seen, to hear and be heard.

We have learned that the arts inspire a profound and personal self-confrontation on a multiplicity of levels: physical, vocal, imaginative, emotional, and intellectual. They also inspire community and the skills needed to function and be creative with and for other people. The rigors of artistic discipline lead organically toward self-transformation. They help break down received and self-inflicted stereotypes by opening both the mind and heart. They produce

curiosity and engagement with life, with self and other. The essential tenet of Stella Adler's work—and the spirit that animates the entire Adler tradition—is derived from the insight that growth as an actor and growth as a human being are synonymous.

Actor training is life-affirming for all young people but has particular relevance for the inner-city youth we serve through our Outreach Division. We have seen it over and over again. The two examples that follow will stand for countless others.

When Darren came to us to study acting, he was lost in his life. He was living on the street and was constantly in and out of shelters. Although he had a guardian who would have provided for him, Darren rejected the offer and bounced from one temporary place to the other. He was making dangerous, risky choices, living a wild nightlife, and just barely passing his high school classes. His acting teachers, advocating self-awareness, challenged Darren to take an honest look at his lifestyle. In his second year of study, Darren had a total turnaround. He announced that he would no longer be known by his nickname, Peaches. He insisted that he was making a change, and indeed he did: he got his GED, enrolled in a well-respected community college, got a part-time job and his own apartment. He also took leaps and bounds as an artist, emerging as an extremely gifted mover and physical actor. His guardian called to say that prior to Adler Outreach, Darren had never committed to a project from start to finish and that he was thrilled to see such big changes in Darren's life. Darren played a leading role in a production that concluded his two years of study. At the completion of the program, he said, "Two years ago I started Stella Adler; I was a troubled kid with a lot of

problems in my life . . . a lot. This program was the only place I felt safe and welcomed; you accepted me and made me feel loved. I grew up not only with my acting but also maturity-wise within this program. Even when I wanted to quit the program, you never gave up on me and showed me that I needed to be here; you knew that somehow this program was somewhat beneficial toward me and I respect that so much."

Max was a high school junior when he came to us. He was born in one of the infamous Eastern European orphanages, and as a young man Max suffered from debilitating depression, at times staying in bed for days, unable to move. Over two years of training, Max slowly came out of his shell. His high school teachers were astonished to learn of his commitment to the program, citing his previous inability to stay enthused about a project. Max grew into a dependable ensemble participant and began to make friends with our college-age students in professional training programs. He made a short film with a student he met in the hallway, and afterward he said that he felt he had found the beginning of a new phase in his life. At graduation he reported, "I used to be shy and hide my true feelings. I wanted to look how I thought people wanted me to look. Now I have more confidence and can say what I really feel. I can look people right in the eyes when I speak. I can speak up even when I know people don't want to hear what I have to say. When something doesn't come out perfect right away, I don't give up. I know that it will get better if I keep working at it. I learned how to be tenacious and believe I can achieve great things if I stick to it and work hard. Stella Adler was one of the great things in my life."

• • •

This book is the product of a longtime concern for the social responsibility of teaching the arts and for the strength and confidence they can provide for young people no matter how difficult their circumstances. In 2008 I produced a panel discussion with Whoopi Goldberg, Phylicia Rashad, Anna Deavere Smith, and Rosie Perez to discuss art and educational justice. The panel was moderated by Leonard Lopate and provided rich testimony that art should be at the center of education, particularly for the financially disadvantaged, where a well-nurtured imagination might be the difference between a productive life of hope and one of despair and soul death. The discussion was preceded by a talk with educators including Maxine Greene, William Ayers, and Frances Lucerna and inspired the idea for this book.

The nationally renowned educator Herb Kohl attended the panel of artists and helped organize the panel of educators. The next day we met and Herb proposed we collaborate on this book. Herb, born in the Bronx like Harold Clurman, and born into a Yiddish-speaking family like Stella Adler, is right at home in this Adler tradition, and it made sense for us to be partners on this project.

One of the things brought to light by the contributors to this book is that in the past, the arts were part of the education experience of even economically challenged American citizens. The elimination of the arts from today's public schools is a relatively new phenomenon. We hope this book plays a persuasive role in inspiring debate, dialogue, and eventually policy whereby the arts take their rightful

place at the center of education in America. We trust that this will contribute to healing some of the abominable conditions in schools today brought about by a model of education with an emphasis entirely on utility rather than on the uplifting and elevation of the human being.

1

"Tears in the Dark":

The Arts as a Vehicle for the Discovery of the Self

Rosie Perez

A native New Yorker, Rosie Perez is loved and lauded for her work as an actress in such films as Do the Right Thing, White Men Can't Jump, *and* Fearless. *She is also revered and respected for her tireless efforts as an activist for education and human rights. She serves as the chair of the Artistic Board of the Urban Arts Partnership, a nonprofit organization that has served over 12,000 New York City schoolchildren in over sixty schools with arts programming. Her work with Urban Arts brings Ms. Perez into New York City schools on a frequent basis, allowing her direct experience with the students. In addition, she regularly testifies in Albany to bring the realities of educational inequality to the attention of New York State's senators and other lawmakers.*

Growing up, I spent time in the Catholic school system, and while the Catholic school system is about higher learning, they would also do a lot of plays, chorus, lots of art things. I remember all the way back to nursery school, there were a lot of arts and crafts related

directly to what we now know as critical thinking. You know—What color is this? What color is that? I was advanced to kindergarten out of nursery school. They marveled that I knew my primary colors. I remember them saying, "She knows her primary colors; she's going to be good in math." It wasn't that I was going to be good in arts, it was that I was going to be good in math. I remember I was in the Peanuts Gang play and I was in the choir, even though I sounded horrible in it.

My first bad experience with the arts was when I went to public school. I wanted to join band and I wanted to play the clarinet and learn how to play the clarinet. The problem was that I didn't have any money to buy the clarinet. I was extremely poor. My mother wasn't able to pay for it, and the Catholic Church wasn't able to help us pay for it, so it was quite humiliating when the band teacher used to sit in class and ask me every single day in front of the entire class, "You don't have your instrument yet? What is the problem?" It was just constant; it was just too much for me. And one day she said, "Why don't you just play air clarinet?" And I had to sit there and play air clarinet. That's how bad I wanted it, but after a while the ridicule just got to be too much and I didn't pursue it, and that's a disappointment to me to this day.

However, I took piano lessons for free from this lady from church, which was really nice, so I can play a little piano. But I think it's a psychological thing that I never went and picked up a wind instrument.

I had great music teachers in junior high school. All the kids of color were really pissed because we were learning about the Beatles, and I was elated because the Beatles were my aunt's favorite group,

and she used to sing "Penny Lane" inside the house all the time. We were studying Paul McCartney, and the teacher was showing us how he used three different melodies within one song and how huge that was and how groundbreaking and how it was like classical music. I remember all of that.

I also remember ceramics because I was terrible at painting, so it was good for me. I had a terrible temper and I used to just love pounding that clay. I used to love to stay after school and do that. I still do ceramics. I love to do pottery.

I think the most powerful thing was when we went on a class trip to Broadway. Some nonprofit organizations had sponsored giving free tickets to public school kids. And I did not want to go because all the kids were talking about the new dresses they were buying, or new pantsuits, or their new shirts and jeans and shoes, and I had nothing new. So I, of course, hid behind my temper and my attitude, and my response was: I'm not going to a stupid Broadway play. I can see it on television, and I don't need to see this, and da, da, da, da. . . .

I remember my aunt working so hard and she bought me a dress from S&M Ladies Wear on Knickerbocker Avenue; it was the cheapest dress. I did not want to wear it. I was humiliated. She took it back and exchanged it for a top and said, "Wear your jeans and wear this nice top." So I begrudgingly went. I literally stomped and pouted the whole way there on the trip.

I sat in the theater, the lights went dark, and the play began, and . . . I was mesmerized. I was the loudmouth class clown, the girl who would fight in an instant, but in the theater I was reduced to tears. I could not stop sobbing, and some of the students were

snickering and I didn't care. Usually, I would haul off and punch somebody instead of letting them see me cry. It's not that I didn't care, but I was so caught up in the moment. If you think about it in cinematic terms, it felt like I was the only one sitting in that theater and the other seats were empty and the rest of the theater was pitch black and it was just me and the performers onstage.

The Wiz changed my life. I mean, that was it. I loved all the other arts I had had prior experience with, but that one changed my life. Only in my house and with my aunt was I able to show vulnerability, was I able to cry. I didn't even like to cry in front of my cousin. And if I did cry, it was usually an angry cry like, "You make me so mad!" And the tears would come out. But it was never out of sadness or joy; it was just anger. And to do that outside the security of my aunt's home and her company was huge. I'm able to articulate it now, but when I was younger I wasn't able to articulate it; I just knew something was different in me.

The other students even treated me differently. I remember I started getting different friends, because the people who were afraid of me would go, "Did you really like the play?" And I'd say, "Yeah," and they'd say "Yeah, I saw you crying." And I'd go, "I wasn't crying." And they'd go, "Yeah, you were." And I was, like, "Yeah."

So I became close to a whole different social group, and the teacher treated me differently, and it just opened me up. The wall that I was living behind didn't crumble, it didn't wash away, but it definitely got thinner. I wanted to participate more in school, especially in English class when we were reading books or in social studies when we were

talking about history and historical anecdotes or stories. Everything became so real to me after that. That was the turning point for me.

I remember seeing the movie *Romeo and Juliet*, and studying the play in school. It prompted me to seek out the arts outside of school. I was an undercover nerd up till then, and it made me come out and express my nerdiness. I remember going to a music store, a record store, and asking them if they had the album to *Romeo and Juliet*. And I played that thing whenever the house was empty or if it was just me and my aunt. I played that thing over and over and over. It got to the point that I got enough courage to play it with my cousins in the house, and my cousin Lorraine was, like, "If you play that record one more time!"

All of a sudden, I didn't care if I was corny. I did not care. I kept buying more records and I remember I had the courage to buy a Beatles album, 'cause that wasn't cool but it was to my aunt's delight. It just allowed me to be the person that I secretly knew I was. After a while, I just didn't care.

I remember having fantasies of being onstage, but I never could do it. I never thought of it being a reality for me, which is ironic now because Spike Lee discovered me and now I'm in the arts. But no, I never imagined it could happen.

What people don't understand about the arts is that they allow you to be a critical thinker and use the right side of your brain. When that happens, you're more inclined to be a reader because you want to absorb the drama. Your imagination is stimulated and it works so much better. When you read a book, you can appreciate it a lot more

because your imagination has been ignited and it has been somewhat trained, if you will. It has been told that you're allowed to imagine and that you're allowed to imagine as vividly and as wildly as possible, so reading books for me was . . . well, I loved it. We would read, say, a little piece of Shakespeare and then do a little play about it, and then I would see a movie about the piece and go back and read the text. And I just kept doing that, back and forth, back and forth. If I saw a movie and I found out that the movie was based on a book, I'd want to go back and read the book.

I had dreams of doing other things, of not being an actress. Once, on vacation, I had almost drowned in Seaside Heights, on the lower east side of New Jersey. I was haunted by the ocean after that, and I remember that coming out in my life and in my drawings. I'm a terrible drawer and painter, but I just kept drawing and molding animals and ocean life, and by the time I was in ninth grade, I said I want to be a marine biologist. That's what I went to college for.

But the arts prepared me for that.

What happened after that incident in the ocean was that I went back to school and, in ceramics, I tried to make a whale. Everybody laughed at me, and the teacher was, like, "That's really nice but we're supposed to be doing lady figures." And I was like, "I don't want to do a lady figure. I want to do a whale." And she said, "Well, that's fine then," and I said, "So?" She said, "You can go to the principal's office." So I went to the principal's office. They were used to seeing me in the principal's office. I used to get detention but I wasn't a bad kid; I was independent, and authority really bothered me. Authority figures really bothered me. So I go to the office, and they don't even

bother with me seeing the principal or the vice principal. I was always assigned to a dean. And this dean and I became good friends; it was actually kind of like therapy. I told him what happened, and he was, like, "Why?" And I said, "I just wanted to do a whale." And he said, "Well, you know, you have to do the assignment." And I said, "I just wanted to do a whale because I almost drowned and I have nightmares about whales and the sea and. . . ." I just kept talking to him and talking and he finally said, "Okay, go back to class." And I said, "Okay . . . I have to do the lady?" And he said, "You have to do the lady, but I will talk to the teacher." And he spoke to the ceramics teacher, and I had to do the lady, but I was allowed to come after class, and I was allowed to finish my whale. So that's, you know, pretty amazing.

I created the Urban Arts Partnership to work within the public schools to engage students in the arts. One kid I work with came to the program when he was around fifteen or sixteen years of age, and he was labeled an at-risk child, a potential problem child because he had dropped out of school so many times. It was because his mother was ill a lot, and he always wanted to spend time with her. He was a quiet, tough kid, and you could tell that he knew the streets quite well, and it broke your heart. He wasn't loud, he wasn't boisterous, but he had a look about him as if to say, "Don't fuck with me because I will fuck with you." He had this very protective shell around him, and of course I related to that.

The entire staff at the Urban Arts Partnership are used to kids like that, so we told him to "come on in." We slowly found out that he had been homeless and had been in and out of shelters with his

mother the majority of his life. We also discovered that he was hiding from Child Welfare Services because his mother was in the hospital and he was living by himself in their apartment. Then the rent was due and he couldn't pay the rent, so he just left and began living at friends' houses, sleeping on their couches. He either went to school or was in danger of being sent to a juvenile detention center because of his delinquency or, worse, of being put in a foster home. That's why he decided, Okay, I'm going to go to school and play this role, have a place where I'm a responsible adolescent of the society or whatever.

His story came out through his poetry, through the poetry program. And that's how we discovered it. His poetry would move you to tears and his intelligence was . . . well, it blew you away. Which made your heart break even more, because the staff kept saying, "Oh, he's amazing, he's amazing, he's amazing." I remember getting really emotional and they're saying, "Yeah, right?" And I said, "No, you guys don't understand. I'm getting emotional because I'm angry. I'm angry about what the world and the system has done to this kid. As intelligent as he is right now, imagine where he would be if we just took care of him earlier? If the system just took care of him?

Thank God that, through our arts program, we know how to help him now. I'm just angry that if he had never sat down and expressed himself through the poetry, nobody would have known what was going on with this kid! Nobody. And, through the program, you have to stand up in front of the class and you have to say your poetry. We don't force them, but we strongly encourage it. When he did, the same thing happened to him that happened to me after I went to the

theater with my classmates. Everyone treated him differently after they heard his personal story—from the teaching staff to the students, even the principal—because he ripped off a layer of that shell so we could see him, so we could see who he really was. He's graduated, he's going to college, and he also just did a short film based on his experience. He produced it and filmed it himself. You just sit there like wow, you know?

What if the arts were not there? What if our program was not there? How would he have been able to articulate his experience to others? How would he have been able to articulate his experience period? Maybe it would have come later down the road; maybe he would have joined the Nuyorican Poets Cafe and done it. But isn't it great that he did it when he did, because now he has more time to grow and get better. And he has more time to enjoy life and more time to let go of the anger and let go of the pain. You can't move on unless you let go.

Here's another story. There's this kid who did not do well in a regular school; he just couldn't pass anything. Still, some teachers recognized that he had this great ability in math and he got into New Design High School. New Design High School was co-created by the Urban Arts Partnership and the New York City public schools. The school was set up to use the arts of design, graphic design, painting—everything that has to do with that type of the arts—to articulate math, science, history, and English. And this kid who was flunking is now graduating this year, with the highest, highest scores. Prior to joining this school and our program, he flunked every single test that had ever been given to him. And the reason is because he had

so much stress to deal with at home. He was actually too smart and therefore the teachers didn't know how to penetrate his mind and his soul. He kind of sat back with arms folded like, "I dare you to teach me. You can't teach me shit."

And he proved them right. He would draw and doodle just constantly. There was a symmetry, a specific symmetry, and geometry to his drawings. His graphic designs are amazing. Now that's what he wants to do for the rest of his life. He wants to be a graphic designer. God knows how he would have turned out if he hadn't had this outlet.

There's a third student I can talk about, a very shy, quiet girl. She was close to her mother; she always had to take care of her little brother. Everyone thought she was just moody and quiet, and had extremely low self-esteem. She was a little pudgy, never did her hair nice. In high school, girls are all about the makeup and the hair and the clothes, and she would always act nonchalant, like, "I don't care, I don't care." She entered our program to go into theater. And everybody's like, "This quiet girl wants to go into theater?"

She got into the theater class. At the time, they were studying *Enemy of the People* and we used the theater class to interpret the book. They had to take an excerpt right out of the play and reenact it and then go back and write about an experience of their own that was relevant to the play.

She asked to play the lead in the performance. And everyone was like a needle on a record, like, "What?" And she said, "I want to be the lead." She was challenged: "Okay, go ahead, be the lead." She was amazing. She always did well academically anyway, but socially she

never clicked with anybody. She developed new friends through the theater and all the other shy girls in her grade started gravitating toward her as if she were the shining beacon for all the shy misfits in the school. She started pulling them into the program as well.

She was in a play that one of the other students wrote, along with this other girl who was way beyond shy. You couldn't really hear her or anything. I was directing them, and I was like, "You need to speak out. You need to have the world hear you. I don't hear you, and if I don't hear you, I won't be able to see you, and if I don't see you, you don't count. Speak out. Let the world hear you." I kept saying this to them over and over and over. By the end of rehearsal, they were so exhausted by me that they had no choice but to do what I said. But I also had made it fun, and they got onstage and they were both so good that all the students were shocked. The other students were, like, "Oh my gosh, you were so good!"

What this is about is self-esteem. Just build up their self-esteem and their confidence and watch them grow. Their teachers—not their teaching artists, but their regular teachers—sent us all these e-mails telling us that this shyest of girls is doing much better in class, and you should see her bounce down the hallways now. She's a whole different person.

The first girl that I was speaking of is now a leader in the school. And you know that's going to translate for her into her college life and adult life. She will be a leader. She always wanted to be a leader but she didn't know how to access it.

Participating in the arts opens young people up in ways that they never thought possible. For instance, there was this one kid in our

program who acted like he didn't want to be there. It's a voluntary program, but for some reason some kids act like "I don't want to be here." He went from ninth grade all the way through his senior year not participating. If he did say something, it was always complaining or putting the program down. That senior year, their assignment was to read and study and enact certain scenes from the novel *Down These Mean Streets* by Piri Thomas. In all his years with us, that was the only piece that spoke to him. After all the years of me going there and him messing up the plays because he had this nonchalant f— you attitude and would never give his all. Suddenly, he was dead-on serious. He was telling the other students, "Come on man, stop playing around. Let's do this." All the kids were, like, "Huh?"

He was such a bully that they actually listened to him. It's a very emotional book. He was doing a scene and got so much into it that all the kids choked up. Now, he didn't cry, but even he got choked up. He looked down at the ground and I said, "Push through your fear. Step into your greatness. It's okay." And he goes, "Yo, but that's not me." And I go, "It's not you. You're playing a character. It's not you at all. You're playing a character, and your character's feeling it, so just keep going with it." And he pushed through and he went with it and it was the first time—and I'm not being dramatic here, you can ask anyone at Urban Arts—it was the first time I saw this kid smile. First time.

Did they do it in front of an audience? No, they did it in front of their class. Does he want to be an actor now? No, but now he wants to go to college. And so it does affect each and every one of them. I have students come back to me who were the wallflowers from the

beginning to the end of the program. Some of the staff said that it was not working for them, but the artistic director would say, "It's working because they're in the class." And they come back with thanks.

Here's a perfect example: I'm in the park on the Lower East Side, Tompkins Square Park, and I'm walking with my boyfriend at the time and I hear, "Ms. Perez!" And I turn around and go, "Yes, may I help you?" And this guy says, "Yeah, I'm so and so, I was in your class. I was in Working Playground." (Urban Arts used to be called Working Playground.) And I say, "You were? What is your name?" And this young man, he tells me his name, and I'm, like, "I think I remember you." And he says, "Yeah, I used to be real quiet all the time and I just want to tell you, I really liked the program. I appreciated it. It stayed with me." That's what it does; it makes them better human beings because they become empathetic human beings through the arts.

If you become an empathetic human being, you become a better member of society. You can have interpersonal skills in an interview or where you work. You learn to collaborate through the arts. We're not trying to produce only poets and painters; we're trying to produce viable human beings who can make this world better. Whether they become scientists or whether they become novelists or whether they become the president of the United States. That's what the arts do. They make you a better human being. I totally believe that, and I think that they are necessary.

Michelle Fine

Michelle Fine is a professor in the social personality psychology program at the City University of New York Graduate Center, and previously taught for twelve years at the University of Pennsylvania. Her research program addresses questions of community development with a particular emphasis on urban youth and young adults and the life within such spaces—that is, the political life of the group and the personal development of the individuals so engaged.

The "spaces" she studies and works within are designed explicitly to be diverse and democratic. They include small, community-based public schools; an ethnic immigration center; a youth group for black adolescent males living in public housing; programs designed to be richly recuperative and supportive for politically marginalized young men and women. She is interested in understanding the relations between these corners of social possibility and larger movements for social change.

Her recent books include: The Unknown City *(with Lois Weis)*; Becoming Gentlemen *(with Lani Guinier and Jane Balin)*; Off-White:

Readings on Society, Culture, and Race; Chartering Urban School Reform; Beyond Silenced Voices: Class, Race, and Gender in United States Schools; Disruptive Voices: The Transgressive Possibilities of Feminist Research; *and* Framing Dropouts: Notes on the Politics of an Urban High School.

Dear Rosie:

You and I met, maybe fifteen years ago, at Bedford Hills Correctional Facility, a maximum-security prison in New York State for women. I was working on the college program and you were collaborating with Eve Ensler of *Vagina Monologues* fame and a writing collective of women locked in prison for eight, ten, twenty years, or life who are, as described on Eve's Web site, "more than just the crimes they committed; they were mothers, daughters, sisters, teachers, Jews, Christians, Muslims, high-school dropouts, PhD candidates, barely 21, pushing 60, barely conscious of their crimes, remorseful to the point of suicide." The women in green were writing poetry and you were performing their words—at the prison—for the women and their children. You were speaking voices that the world has refused to hear, voices of women behind bars, who walked in lives perhaps not very different, but so very different, than your own—or mine. Eventually your amazing collective of activist performers produced the documentary *What I Want My Words to Do to You.* You understood intimately the power of performance on writers, actors, and audience. No one can be a bystander.

One evening in the late 1990s, onstage at Lincoln Center, you

performed the story of a woman in green whom I knew well and loved. As the lights went down, the curtains opened, the tears fell. With Mary Alice, Zoe Caldwell, Glenn Close, Ruby Dee, Hazelle Goodman, Mary Beth Hurt, Phylicia Rashad, and Marisa Tomei, you spoke the words of the women caged behind bars because when they were children they were told to play clarinets in the air, because they had a rage they couldn't contain, because they were poor, beaten, neglected, struggling for a world not yet realized yearning for love from a mother who couldn't, a stepfather who abused them, a man who asked them to hide his gun, a child who screamed and screamed until she didn't. And so someone died, or drugs were sold, or a terrible, life-altering mistake bled onto their life story. And the women were sent away. Banished from our collective imagination, rarely visited. Forgotten. Until you spoke the words at Alice Tully Hall on Broadway that interrupted our collective dissociation and forced us to hear the women, let the words pierce our bodies, make us weep and organize for justice.

So I read you now, Rosie, with the complexity of what you say about your life and vivid, embodied memories of my bearing witness as you midwifed words from women who were/are not allowed to speak in public, for themselves.

Your essay, which I call "Tears in the Dark," speaks to the power of the arts in young lives. You help us understand the arts as an opportunity to metabolize anger into activism; to try on other ways to be; to stop "hiding behind the shield of anger"; to embody others' stories/lives; to know it might be otherwise; to listen with intent for justice denied; to live in the subjunctive,

imagining what might be and insisting what must be. I ached when I read the image of you playing clarinet in the air and thought about so many children of color and poverty—tattooed with a shame on you, shame in you, as I imagined shame curdling in the body of little Rosie, wrapped in a dress that contaminated her already-digested embarrassment. But then you also speak of *desire*, "That's how bad I wanted it." Desire is like a flame hard to extinguish. Anger may be the voice of desire denied, curdling, burning a hole in the soul.

With your essay you allow us to witness a journey from alienation to engagement, from shame to solidarity, through music, the Beatles, pounding clay, banging out the demons, a visit to Broadway, and then another, the darkness of lights down, stage alit, tears flowing, new friends, new expectations, a voice worth speaking and then louder, protesting Vieques, getting arrested, HIV/AIDS activism, and smuggling the words of women long exiled back onto the stage at Lincoln Center.

You learned the power of words and performance; placing your body on the front lines of breaking the silence, you evoke a response. In performers and audience. Today you carry that wisdom forward, massaging the voice boxes of betrayed youth around the city.

What I love about your essay is the journey from cowering behind shameful anger to activism derived from righteous anger, the journey from silence and rage to voice and entitlement, from isolation to community. Twice in the essay you mention *hiding*—when you were "hiding behind my anger" and then when you

were helping a young homeless boy who was "hiding from Child Welfare." You know, in your body, memory, and commitments, what it means to hide, to be enflamed by rage and then to enter another character, to take her onstage, to find new parts of yourself, to wander through your selves, to funnel the courage and generosity you have experienced to reach into the keloid-covered body of a child shrouded in shame, hold his hand, and say, gently, come with me, we'll find yourself.

There are those of us who are also committed to doing the work you have dedicated yourself to. Polling for Justice is a project with youth in New York City. It is a participatory action research project by and for youth, adolescents from across the city. Handing out surveys on the streets, in parks, at youth organizations, after-school programs, and on the Internet, youth and adult researchers have gathered rich, wonderful information from more than 1,000 youth: African American, private-school students, multiple ethnicities, Latino, rich, Asian, GED earners, Muslim, Jewish, white, queer, in special education, undocumented, privileged, homeless, formerly incarcerated, dropouts, and headed for the Ivy League.

What's amazing about the data we have analyzed thus far is that even those youth who have been betrayed systematically by racism, poverty, public institutions that turned against them, and intimate kin who abuse, these same young people tell us they yearn to be educated, respected, to participate in civic, artistic, and political matters. They want to belong.

In the spring of 2009, we turned our research toward

performance, reflecting your sense of the power of theater. We were inspired to learn that almost one hundred years earlier, in 1913, W.E.B. DuBois produced a pageant called *The Star of Ethiopia*, a "great human festival" with a cast of a thousand African Americans. The youth researchers began collaborating with spoken word and visual artists, improvisational and playback theater, graffiti- and mural-making performers. We stepped into the jazzy intersection of science and art hoping to circulate evidence and outrage, between lives in pain and privilege, within the bodies of performers and the souls of audiences. It was through the arts that we found the necessary vehicle for expression of our experiences.

Whether we consider your Broadway experience, the Urban Arts Partnership, or Polling for Justice, the arts offer a landscape of invitation, seduction, and transformation. A platform for individual and collective engagement, as you so beautifully describe, the arts provide an opportunity to break through walls, to come to know self and others and spin an intimate web of solidarity. As school districts start to slash budgets, I worry that children, particularly poor children of color, will be invited to play clarinets, paint, dance, and perform in the air.

Michelle

2

"Communication from One's Heart":

The Arts and the Development of Self-Discipline

Phylicia Rashad

In addition to being America's favorite mom in her role as Claire Huxtable on The Cosby Show, *Phylicia Rashad is also an award-winning stage actor of renown. Her Broadway credits include* Cat on a Hot Tin Roof, Cymbeline, August: Osage County, Jelly's Last Jam, Into the Woods, The Wiz, *and* Dreamgirls. *She was nominated for a Best Actress Tony award for her work in August Wilson's* Gem of the Ocean *and won the 2004 Best Actress Tony for* A Raisin in the Sun, *making her the first African American woman to win in the lead-actress category. Phylicia Rashad grew up in a highly creative family in preintegration Texas. Having graduated magna cum laude from Howard University, Ms. Rashad has long been dedicated to the importance of the fine arts in education. Her work as a speaker and advocate have earned her Harvard University's Foundation Award. Her extensive commitment to charitable and nonprofit organizations includes her work on behalf of the PRASAD Project, the Children's National Medical Center in Washington, D.C., and Recruiting New Teachers Inc.*

I was thinking about my education and how privileged I feel to have enjoyed that education. I was educated by people who educated my father and his siblings. I grew up in a family of educators and I had teachers who insisted, "You're going to learn this and you're going to learn it well. You're going to master this. You're going to master this because you can, because I say so, and because I know where you live." That's a very different kind of education than my children received here in the schools of New York. I grew up in Houston, Texas, in a time of legal segregation. I did not feel deprived of anything because I wasn't.

The arts were very much a part of our education. It was a time when the school board owned instruments and anyone who wanted to learn took the classes, and we checked the instruments out at the end of the day and they were like a badge of honor. I remember walking around with my viola thinking I was just great. My sister played bass, my brother played trumpet. There was drama, there was an a cappella choir, there was an all-girls choir, there was glee club.

This was not a city in which there was one African American community; there were several. There were six high schools. There were two junior high schools feeding into each of the six high schools and there were three to four elementary schools feeding into each junior high school, so it was big.

My mother would not allow us to speak in slang at home. She was from Chester, South Carolina, and she was forever correcting our speech. When I was in the sixth grade, because of my speech patterns and the level at which I read, my teachers decided to groom me

to audition for a citywide music festival with the elementary schools. I was to prepare to read the libretto from the *Musicians of Bremen*. This was not even a real operetta; it was just what appeared in the back of our sixth-grade music book.

At that time, music was taught in the public schools, and all of the students in the Houston Independent School District received education this way. They prepared me every day. I was not able to play in the school yard before school or after school because I was being groomed, and that meant reading the libretto over and over and over again. This would be my introduction to not being able to do everything I wanted to do socially later on in life because of a commitment to work. But I didn't understand it at the time; I just thought it was cruel and unnecessary treatment.

Now I see that these teachers did this on their own time. They were not getting paid to do this. Our teachers did things they were not paid to do; they did it because our development was important to them. And that is true. And I can give you examples of that from elementary school on through high school. There were teachers who gave their time, before and after class, for things they were not paid to do.

They had me read this every day before and after school, and the reading wasn't just reading. They were correcting inflections at the ends of sentences, encouraging and insisting upon expression with the words. They were grooming me. And when the day came for this audition, there was a student from every school, representing each school, and we went before the school board to read. And at the end of those auditions my teachers came to me and said, "They don't

want you to read the libretto; they want you to be the mistress of ceremonies for the entire festival."

That meant more time out of the school yard, because now I had to prepare mornings and afternoons for the festival. And when the time for the festival came, I stood in the spotlight for the first time. And because I had been so prepared by my teachers—even though I held the script in my hand in a very lovely folder with musical notes in glitter on the outside for the people to see—I didn't have to read it; I knew it by heart. So I stood and I talked to the light. And at the end of that program, as the mothers were coming to collect their children from the stage and exit the coliseum, I heard several of them say, "There she is, there's the little girl who spoke so beautifully. Isn't she beautiful?" And in an instant I thought, *When I grow up I'll be an actress. I'll play in the light and be beautiful all the time.* Well, what I didn't understand but would come to understand later was that the beauty that I had experienced had nothing to do with what I was wearing or what I looked like; it was the beauty of communication from one's heart.

I think that we all carry things within us, and when we're very fortunate we meet with people who offer experiences that allow us to be in touch with that. Even if we don't fully understand the experience as a young person, in time it can unfold.

In those days we had forensic tournaments, and in a forensic tournament there would be areas of competition. There would be debate, there would be one-act tournaments, there would be monologues, there would be readings. And our teachers worked with us and

transported us to wherever we had to be in the city to participate in those things. Nobody reimbursed them for the gas money or the time.

Another thing: as a high school student I was a majorette, and Mrs. Winifred Sheila, who taught the girls' choir as well as organ and French, was the majorette sponsor. And as the majorette sponsor she took it upon herself to find a twirling expert. In New York this doesn't mean anything, but in the South you'd have to learn how to twirl the baton for real—none of this fake figure-eight stuff. If you were going to be a real twirling pro you had to use your fingers, too, and for that you needed a real teacher. She found a teacher (and this was during a time of legal segregation) on the other side of town, but we had to go to her studio. Once a week, Mrs. Sheila piled the majorettes in her car, as did the one who was her co-sponsor. They piled us in their cars and they would drive us to the other side of town every week, and this was after teaching all day, with lesson plans to work out and tests to give and their own families to care for. And it was not a short trip, because Houston is large. They would do things like that.

When I was a student, school was a language-rich environment. We were taken to plays; we didn't just have them in the school. We would go to the theaters to see them. They would organize that; our teachers would go out of their way to organize that for us. But also in the school system things were being offered, too. Every year there was a time when we would go to listen to a concert by the Houston Symphony Orchestra at the music hall. For children, this was a great

outing, and we would bring our fifty cents, and for fifty cents we'd get on the bus and we would go. On one such occasion, my brother, who is older than I am and who was at that time in the sixth grade, conducted the Houston Symphony Orchestra as they played "Stars and Stripes Forever." I'll never forget it. We had things like this.

Oh my goodness, when I say these things now it almost seems like a fairy tale, but these are things that children today in private school experience. My daughter attended a private school and they had these things all the time, but not at any of the local high schools. This certainly doesn't afford these students multiple opportunities to stimulate the imagination and to see themselves, to dare to see themselves in many lights, in different lights; to explore their capacities. It doesn't afford them that, does it?

At one point before that occasion in the sixth grade with the music festival, I thought to become a pediatrician. My father was a dentist; there were a number of dentists and doctors in our community. These were families that associated with each other; they were integral parts of the community. And this is what I was seeing in my home, and that felt very natural to me. And at another point it felt almost natural to be a teacher because there were so many educators in my family; there were so many teachers. Those things, you know, it's what I saw in my community and what I saw in my home. And I enjoyed science studies. I studied all the sciences: biology and chemistry and physics as well as different branches of mathematics in high school. We had the basic arithmetic, yes, but then there was Algebra I and II, then Geometry I and II, then Algebra III and IV,

and then Trigonometry. I studied all those things. And I had to be a good student because I wanted to be a majorette, and you couldn't be a majorette if you didn't have a B average. So it all worked hand in hand.

All this contributed to building myself as a student. My introduction to fractions came to me in my living room at the age of six, when my mother brought all of our neighborhood friends inside and began to explain musical note value by cutting up these candied Easter eggs and demonstrating. "If this" (she held up an Easter egg, I'll never forget it), "were in 4/4 time, this is considered a whole note, it gets four beats. Four beats to the measure." And then she proceeded to cut it in half and then in quarters and then in eighths and then in sixteenths. That was my first introduction to fractions.

All of this learning and experience rounds the human being out. Not all of the students who studied music (and there were many of them who played their instruments very well) were going to become musicians any more than all of the students who attended the plays, read the plays, analyzed the plays, performed in the plays were going to become actors. But the point was that that was an integral part of your education. It was there for you, the way the branches of mathematics were there for you, the way grammar and literature were there for you, the way the science studies were there for you. It was there for us.

Every day was full of promise, and sometimes trepidation if you hadn't studied well for the test, you know. But every day was a day to be looked forward to. Every single day.

I loved school. I loved being in the ninth grade playing Vivaldi's

violin concerto. I still remember the fingering for *Eine Kleine Nacht-musik*. I remember it to this day. I had occasion recently to speak to my music instructors: Mrs. Harrison taught us in elementary school and Mr. Harrison taught us in junior high school. Mr. Harrison taught band and string orchestra. It was there that I learned to play the viola. I still remember the fingering, and when I saw him recently, I told him, and I began to play. I began to finger in the air and bow in the air and hum the viola part to *Eine Kleine*, and he said, "I don't believe it." And I said to him, "You don't realize what you gave us. You don't realize how much you gave us."

We used to have in elementary school that which is called "Music Appreciation," and in the music appreciation sessions we would listen to classical music. We would receive instruction as to who composed it, and at the end of, let's say, a six-week period of that kind of activity, we would be given a test. It wasn't for a grade; it was for a certificate. And if you did very well, your certificate had a blue ribbon on it. It was like a badge of honor.

In elementary school, Mrs. Harrison, who would come in once a week, decided that our school should have an a cappella choir. Imagine it, in the sixth grade singing the *Lord's Prayer*, singing *Lord Divine*, the *Hallelujah Chorus* a cappella. We did that. Those sessions were after school, and nobody paid her for that. And then in the spring there were concerts, all the families would come to hear, all the parents and grandparents and aunts and uncles. People took joy in that. And in junior high school it was the string, band, and orchestral concert. The families would come.

Imagine my shock many years later, when I'm on television in *The*

Cosby Show and I happen to be at the Superdome in New Orleans for the Bayou Classic and I encounter an administrator at one of the junior high schools that was in the community in which I grew up. Somehow in our conversation I mentioned the importance of instruction in the arts for me when I was in school, and she said, "Oh, we don't have that anymore." And I said, "You don't have it anymore? Why?" She said, "Well, someone on the school board decided that if parents couldn't afford to buy the instruments, students wouldn't want to play them." I never owned a viola. The viola that I played was owned by the Houston Independent School District. And I could check it out every day of the week and I could even take it home on weekends to practice, as all students could with those instruments. There were very few students who actually owned their instruments.

I don't know what's happening in the Houston Independent School District now, but in the community in which I live, I see what happens and doesn't happen unless the administrators and the teachers take it upon themselves. They say there's no funding, but there wasn't any funding then.

Just an aside on all of this: I gave testimony before the City Council in New York City on the importance of education and the arts. There were some administrators and other people from the school district there, people who make the decisions, and what I perceived was shocking. I understood that they felt that the arts should not be given importance in the schools, and this sentiment wasn't coming from the councilmembers but from within the Department of Education. There was an agenda. I remember sitting there as the assemblymen asked questions of these administrators—people who sit

behind desks, who are not in the classroom—who set the program for the year, who make the decisions. They hire an art teacher and have the teacher teach science.

And they couldn't answer questions clearly, simple questions that were being put to them. And I looked at them and I realized: they are carrying out a policy that denies the importance of the arts in the schools.

It's unfathomable. Creativity exists in every human being. Before children speak they sing; as soon as they can stand to walk they're skipping and dancing freely; and before they learn to write, they draw. This is fundamental human expression we're talking about. This is not pie-in-the-sky, new-age elitism; this is fundamental human expression. When we want to know something about past civilizations, we study their art in the form of jewelry, pottery, frescoes, cave paintings, the cloths they wove, and the architecture they developed—is this not so? This is what we study, that and the wars they fought.

I have a niece who was an art major, and she entered the school system as a teacher, and she was teaching children with Tourette's syndrome. She used the arts to teach; she used her knowledge of art to teach history, literature, and science to these children. She developed a program that allowed her to get through to them.

Sometimes people mistake the importance of arts education because they do not understand the intelligence and the disciplines that are involved. And when you don't understand that, it's very easy for you to say, "Oh, those people just get up and do what they do." But nothing could be further from the truth. Tremendous discipline

and great intelligence are involved in the arts. There is no art without them. It is not unusual for people who are not in the arts—but who enjoy hanging pictures on their walls and buying recorded music and going to an evening in the theater—to not recognize the intelligence in them. They don't recognize the discipline, they don't consider study. They don't consider preparation, they don't consider sacrifice, because they don't understand the discipline involved. They think we just get up and do what we do.

When young people are privileged to have an arts education, there's a sense of accomplishment that accompanies this. Also, there's a camaraderie built among the students, that is fostered among the students, because so much of it is teamwork; you're building together.

And it does carry over to those things that are considered academic studies, and that's been proven. It's been proven that arts in education supports the student in academic studies. I don't know how many times we have to experiment with this before we accept it. Because visual arts involve knowledge of light, vibration, color, nature, physiology, biology, all of these things. Just in visual arts alone, just in painting alone. In dance, you must know your anatomy. Music is based on rhythm and intervals, and the root of all that is mathematical. That's basic arithmetic right there. In theater, you get the culmination of everything, plus the importance of language, the value of language, the power inherent in language. And then there's also the study of psychology, because you have to understand human behavior if you want to portray it honestly and authentically. This goes into architecture as well. You're studying principles of

physics there. Yes, there is tremendous discipline and great intelligence in all of the arts.

Arts education affords students self-expression, self-discovery, self-inquiry. There are people who would have other people be like robots and machines. Now, we as citizens must decide: what kind of society do we want to have? Do we want to have a society, a culture, a nation of robots? Or do we want to have a nation in which every single child is afforded the possibility of complete and full development of his or her human potential?

Lisa Delpit

Lisa Delpit is the Felton G. Clark Professor of Education at Southern University in Baton Rouge, Louisiana. A MacArthur Foundation "genius grant" recipient, Lisa Delpit is the author of Other People's Children, *a paradigm-shifting book on the role of race in the classroom that has become a classic text among educators and others striving to improve the quality of America's education system.*

BECOMING DIVINE

According to the tenets of traditional African belief systems, each child comes from divinity, and the purpose of education is to grow toward our divine birthright—to reach toward perfection, to become more like God. How does one become more "godlike?" Is it through mastering test "bubbling"? Through memorizing dates in history? Through practicing mathematical algorithms? Through sitting quietly at a desk? Could that possibly be? Rather, I believe it is through a profound involvement of the intellect, the body, and the

spirit with the world around us. It is through seeing, feeling, touching, hearing the world, and then, through our phenomenal selves, transforming what we have experienced into new insights, new visions, and new creations. If we are the instruments designed to express divinity, then true education must be the vehicle to hone those instruments to their perfection.

And how do we do that? I believe that what we call "the arts" provides a template. Phylicia Rashad recalls from her childhood the people who offered experiences that allowed her to be in touch with the magic she carried inside her, education "that delivers the human being to himself." When we see a child through the lens of the arts, we have greater potential to see the child not only as he or she is, but as he or she could be. Just as Rashad's teachers recognized something in her that they were led to "groom," we can see a child's strengths rather than his or her challenges.

Suddenly, the little boy who can't sit still, jumping and tumbling around the classroom, can, with a new set of lenses, become a dancer. The girl whose school papers are covered in scribbles becomes an artist. The boys who annoy their teachers by constantly tapping on their desks with pencils become drummers. Those whose notebooks are filled with raps become lyricists, and that little girl who cries at the least affront becomes a thespian. The arts give us new eyes to see the potential for the expression of divinity, for perfection, in our children. They also give us the opportunity to "groom" children to perfection rather than to constantly seek their deficiencies—giving them and us a secure belief in their "perfectability."

After all, isn't what we call the arts what our children do in their

most natural expression as they learn to live in this world? One need only spend a short time watching a toddler or a kindergartner interact with the world to see movement and dance, the creation of music with voice or "instruments," visual expression through any available media—using all senses to explore and transform their environments. This is what children do. But what do we ask of them when they come to school? Typically, we ask that they give up every natural instinct. Rather than help them discipline their natural instincts to perfection, as Rashad's teachers did, we ask them to abandon every tool they have used to learn about the world, to sit still and listen.

When my own creative, vivacious daughter started first grade, she was so excited to be going to "big-girl school" that she wanted to go to sleep on Friday and not wake up until it was time to go to school on Monday so she wouldn't have to wait so long. After the first week, though, she was so discouraged about what she had experienced that I could hardly get her to go to school at all. When I visited the school to try to find out what the problem was, the principal told me that the purpose of first grade was to learn to sit at a desk, and that my child was failing miserably! Too many of our children fail school because school fails to see *them*.

I had the amazing opportunity years ago to visit the Reggio Emilia preschools of Italy, described by education pundits as the best preschools in the world. The schools are based on using the arts to teach young children. I will never forget the sight of diapered babies—many of whom could not yet walk—sitting and crawling around outside on large pieces of newsprint, exploring, when they

had a mind to, the pieces of charcoal wedges around them and making marks on the paper. There was a "teacher" sitting near every two or three babies who would occasionally demonstrate a specific way to hold the charcoal, or a way to create shading, but the babies were free to imitate, explore, or ignore.

By the time these children were in the three-year-old room, the art they created was phenomenal. They had acquired the knowledge and skills to use—with no admonitions to be careful—sharp pieces of glass in mosaics, pointy and sharp professional clay-working tools, and real china in the dress-up corner. By the time they were five years old, they were studying the science of motion of the earth by exploring shadows, learning the physics of light and color spectrums in prisms, and graphing mathematical proportion to create to-scale drawings and clay replicas of dinosaurs and skyscrapers. They wrote and performed plays stemming from their "play" in the dress-up corners. In short, these young children not only expressed themselves through the arts, they also, as Rashad suggests, learned what we consider to be mathematics, the sciences, and literate writing.

Something must also be said of those phenomenal black women and men who were Rashad's teachers. There was something in many of those individuals, those "other mothers" and "other fathers" as they have sometimes been called in the literature on black education, that drove them to demand the best of their students and of themselves. This was during a period of extreme segregation, when the teachers could not expect to receive the societal benefits that their educations would have provided had they been white. Yet, they

pushed themselves beyond any reasonable job description to provide for their charges experiences that these children could not possibly otherwise have had.

As Phylicia Rashad details, these teachers used their own cars, money, and time to transport students across town or even across the state to allow them to visit museums, to attend plays, to receive specialized lessons, and to participate in competitions. They worked with students on their own time to perfect the gifts they perceived to be hiding in the souls and minds of the young people they taught.

When I interviewed a group of highly successful African American men who would not have been expected to achieve in life given their economic backgrounds, to a person they credited one or more teachers for their success. There are many, many teachers today who also go well beyond the call of duty to help students excel. When we give of ourselves to our students, when we demand discipline and excellence from them as well as from ourselves, our students excel. (Although I must add that we shouldn't have to do this out of our own pockets and against the current. Were we truly about educating our children, such attention to the arts would be built into every school's curriculum!)

When my daughter was in elementary school, she wanted to join a community orchestra, the Still Waters Youth Sinfo-Nia of Metropolitan Atlanta. This orchestra, often praised for its musicianship and invited regularly on international tours, was composed of mostly low-income black and Hispanic children, most of whom did not have access to musical instruction outside the orchestra's confines since by this time in our educational "development," there

was little to no music or art in the poor, urban schools. The director, Mr. David Robinson, and the conductor Mr. Orlando Moss, did not require any payment for the extensive training and face-to-face time they provided to students.

I will never forget the night of my daughter's first rehearsal. She timidly entered the door, and although Mr. Moss greeted me briefly, his total attention was immediately diverted to my daughter. "It is good to meet you, Prodigy!" he greeted her, while shaking her hand. Each child who entered received the same greeting. Over the course of the year, Mr. Moss demanded a lot of his students. The rehearsals were long and grueling. If something wasn't perfect, they would review and review. Many times waiting parents were grumbling and falling asleep on the bleachers, but Mr. Moss would not allow for anything less than he knew the children were capable of. "Young ladies and gentlemen, please take out your writing utensils and mark measure thirty-five. I know you are tired, but I know you want to be excellent, and we must practice this section at least ten times to reach toward excellence." The student musicians never complained. I believe they adopted the vision Mr. Moss had of their potential. They worked toward perfection.

It is through the perfection of our gifts that we reach toward divinity, and the arts allow us a lens to see gifts that may not be immediately evident. It is through the identification and cultivation of the gifts our students bring to us that we create a path for their perfection, a path to their divinity—and, if we do so in our chosen role as teachers, a path to our own.

3

"An Affair with One's Soul": The Arts and the Development of Cultural Identity

Frances Lucerna

Frances Lucerna is an artist, activist, and educator whose incredible achievements inspire the rest of us to consider sleeping less and changing the world more. Ms. Lucerna looked around her Williamsburg, Brooklyn, neighborhood in 1980 and was dissatisfied by what she saw: derelict buildings, misguided young people, drug use, disease, and unrealized dreams. Together with a group of concerned citizens, Ms. Lucerna set out to change this and change it she did. She founded the Williamsburg Arts and Cultural Council for Youth, a community performing and visual arts program for adolescents, and in 1982 she became co-founder of El Puente, a Brooklyn-based community/youth development organization. Ms. Lucerna, an advocate for the recognition and support of community-based holistic arts services and institutions, has broken new ground on the frontier of national school reform through her work with El Puente Academy for Peace and Justice. It is one of the only schools in the country dedicated to human rights and a nationally recognized model for CBO (community-based organization) schools. Ms. Lucerna enjoyed a thirteen-year career as

a professional dancer prior to founding El Puente. She and fellow El Puente co-founder Luis Garden Acosta received the Heinz Award for the Human Condition in 1998.

Growing up here in the community of Williamsburg, Brooklyn, being a young woman of color, coming from a rather traditional home in the 1950s and 1960s, and being educated in the Catholic school system, I had a narrow lens through which to experience my capacity for "becoming" in the world. There were just very few options. But when I encountered the arts through a summer program that introduced me to the world of theater, and particularly dance, it was truly a transformational moment in my life. It was something that resonated deep in my soul, in my spirit, and allowed me to experience myself, my own potential, my power, in a very visceral and deep way. It allowed me to have another way of looking at the world and my options and even the way in which I carried myself in the world.

When I grew up in Williamsburg, there were no organized arts programs as we know them today. My parish church held a summer program where a seminarian, who was a singer—an opera singer— and a theater person taught us. I never aspired to be a dancer or an actress. I was told I needed to be a secretary, or a teacher, or I'd get married and be a mom (which I am, and which I'm very proud of). But the possibilities were very limited. And those five summers that I spent on a stage in Williamsburg are where I found a whole new world, a whole new sense of self. Something I had never imagined within myself. And I think that's what connects the issues of

education, justice, and the arts. I think it's important to go inside yourself first and then go out.

That experience in my early adolescence and the transformation that happened for me is the jumping-off place, is the place where I have continued to live and grow and work. I strive in my own way to create that kind of potential for young people. In the last thirty years of my work with young people—particularly here in Williamsburg in my community, as I came back to my community after dancing professionally, and then in my development of El Puente—I have tried to connect young people with their selves.

The El Puente Academy for Peace and Justice was one of the first small New Vision schools here in New York City, and I had the honor and privilege of being its founding principal. I would be asked, because of my unique background as an artist and an activist co-founding a community-based organization, what motivated me to become a New York City public school principal. I would always answer: my experience and sense of myself as an artist. I think that was the greatest training. It gave me the greatest insight. It certainly gave me an understanding of what is, in terms of education, sacred.

Our work at El Puente has given young people the opportunity to have a window into their own souls: not only a window, but a door to go deep within themselves. Adolescence is a tumultuous and very difficult time in one's life, and in each and every one of us there lives an unresolved teenager. There's so much about the process of "becoming" when you're a teenager that is perilous and often lonely. And the arts provide an opportunity for young people to cultivate the inner life, and get in touch, in a deep way, with their emotions,

with their feelings about themselves and certainly about the world. Not only to experience them in a deep way but to transform them—translate them into something that's tangible, that's visible, that can be connected to others. This happens through the arts.

This can be extremely important in a young person's life, truly transformational. The process of having what I call an affair with one's soul is what I think has been the thing that has most moved me and what I have seen as so powerful in terms of the arts and young people. It allows them to take that experience or that transformation, be in that transformation, and then see the world in a different way and commit themselves to a different, more powerful, and open way of living.

When I think about specific examples of students at El Puente for whom the arts have been transformational, what comes to mind is a collage of so many young people. Maybe the ones that I think about most are the young women who started in my first dance program. I started a dance program here in the community with a group of young Latina women, many of them about ten, eleven, twelve, thirteen years old; they had asked me to start to teach a dance class, which I did, during a time I thought would be my transition back to the stage after an injury. It turned out not to be, but the class turned out to be the path to my vocation with young people.

I remember this group of young people so well, and I had an opportunity to stay with them and continue to be their mentor and their teacher for the next decade. Many of them became veteran members of what we call the El Puente Dance Ensemble, a group of young men and women dancers at El Puente who, with the assistance

of my co-director, Brendan Upson, actually made the transition to professional stages.

I remember those young women as being reminiscent of myself; most of them were Puerto Rican, Dominican, first generation in some cases, or actually arrivals from the Dominican Republic with their families when they were younger. Modern dance was foreign to them. I remember them taking the class, and slowly but surely I started to see these young women just physically become very different, start to be in their bodies in ways that were extremely powerful. This kind of confidence, this kind of connectedness to the power of their bodies and expression was amazing. And I remember one in particular, Mari, who really became the star, and she is still in my life and has gone on to become a professional performer, dancer as well as actress, and also an activist. And I remember you could tell she had star quality. I remember saying to her at some point, when she was eleven, twelve, "Mari, we need to think about going and auditioning for PA," the School of Performing Arts. She looked at me and she goes, "What's PA? Is that, like, Public Assistance?" She didn't even know what that was. And I said, "No, no, no, this is a public school for performing arts"; it was at LaGuardia High School near the Juilliard School in Lincoln Center.

I coached her. I also had to do a lot of coaching with her mom, because her mom thought, "Why is she doing this? And why would you even think about supporting her in going on to even think about this as a profession?"

I remember many, many conversations with her mom, sitting with her, and trying to explain to her that this was really important.

What was at stake was Mari's connecting with what really moved her and what she was passionate about. It might lead to a career in the arts, but what was more important was giving her the confidence and groundedness to make a real decision about following her passion in life, and being passionate in life.

She said, "Mari's not gonna make money doing that, right?" I went through days with her and Mari, considering Mari's future. It was a process of empowerment for Mari, and also a process of transformation for her mom. She embraced Mari's feelings. Mari did go on to get into the School of Performing Arts, and was a star there. Then she went on to New York University.

Mari is extremely powerful and thoughtful, she's extremely soulful, and she's an amazing, amazing, amazing performer. There were a number of solos that she did in the El Puente Dance Ensemble. She's gone on, and every time I've seen her perform professionally, I'm always moved. She really connects with her audience in a deep way and makes them feel in a deep way. I often wonder what it's meant for her to have been able to find that in her life, and to be able to pursue the arts in her life, to be the dancer and the actress. It's allowed her to live a life she could not even have imagined if that had not happened. Where would she have been?

I think of Mari as an example of many of those young women in that first class and in the El Puente Dance Ensemble, many of whom have gone on to other careers. I've always been struck by their willingness to push the boundaries, to be courageous in their decisions in life, and to be confident in who they are as women and as people. They are deeply caring people. These were young women who had

the same kind of beginnings that I did. Some went on to become professional artists, but others went on to have other kinds of very successful lives. And I know it was because of their experience with the arts early on in their lives.

At the El Puente Academy, we think every single person is gifted, and that the community and school are interchangeable. We are fifteen years old, we've had thirteen graduating classes of young people from our community in Williamsburg. They are those young people who would probably have gone to Eastern District Comprehensive High School. On a range of one to four in terms of reading and math scores, they are ones and twos. Almost all of our young people are bilingual; even though they may speak English, their parents at home speak mostly Spanish. They come from poor communities, so they come from poor families. And most of them have no high school graduates in their families. Yet, in all, we have had a 90 percent graduation rate every single year and a 90 percent college acceptance rate.

I think of one of our students who worked with our muralist Joe Matunis. The style and the technique of Joe's work is extremely provocative and moving. He and the muralistas of El Puente have done maybe eight major murals in the community, and one of them is across the street from my house. (As an aside, I have to tell you that Williamsburg is sort of the hot spot of the world now. They have tour buses that go through the neighborhood—can you imagine? And one of the stops is the mural, this "no-smoking" mural across the street from my house. The bus stops and everybody gets out and takes pictures of this mural which has images that speak to smoking

and the evils of smoking and the kinds of things that it does to your body and to the environment.)

Joe also did one very recently in Bushwick about the history of Bushwick: all the way from the burnings in Bushwick to the hopes and dreams of the community. He creates murals that engage the community in intergenerational dialogue.

Joe works with young people who traditionally and historically are what we call "challenged." I think of one in particular that he worked with who barely spoke. He was so introverted that you couldn't get him to speak. The work that he did was provocative. You could see how deeply he thought about things through his artwork.

Most of the young people that Joe has worked with over the years would have been lost in a traditional school—young people who were, because of their circumstance in life, or maybe because of their challenges in terms of their academics and their learning needs, the kinds of kids who would be marginalized. And working with Joe, they really found their place.

The one young man in particular that I think about, Angel, had real serious issues, and was on medication. It would have been challenging for him to navigate through high school, and he was one of Joe's guys. He worked with Joe and then he started to get himself into the drama class. Through our integrated arts project, he stood out. His talent was voices. He became the voice behind the screen, the voice behind the big puppets that Joe would make. He would come out onstage and people would just stand up and give him an ovation. And this was because of his work with Joe, and also his work in the arts, starting with Joe's class and then transforming into this actor.

He has since gone on to college and is studying acting. I mean, go figure. Many of the students Joe worked with have been transformed. These were young people who in other settings would have been extremely challenging and would have been marginalized. They found their voice or their passion.

In the El Puente Academy, arts are infused throughout the curriculum. It is purposeful and intentional. Teachers team with artists in some cases, or the culture there is just such that most teachers find the artist inside themselves and then infuse it most effectively through their core curricular teaching and the instruction that goes on at the academy.

We have started to help other schools use these ideas to allow young people to open their minds, to think, imagine, and process ideas in complex ways. Our ideas about the arts and learning not only have personal impact but also enhance intellectual development. We place a lot of importance on academics in a narrow way and are concerned about how students perform on tests. But really, the act of learning is the act of becoming and becoming fully human. That's where I think the arts play such a dramatic role.

For us, everything starts with the creative process. It's the way we bring people together to engage in dialogue. We talk about this process of "see, judge, and act," where we look at the world around us and look at the situation—particularly maybe in the community—or a certain issue that's impacting us, and then we have this dialogue around it and research it and then we create these action plans to make changes.

As we open up possibilities of thinking about these issues

dynamically, we develop ways to express them and teach about them through the arts, whether it be through a mural, a drama, a one-act play, a piece of choreographed dance. We try to develop works that will translate the impact of this issue on our lives and suggest creative strategies for coming together to make change. Once you get people hooked into their passion and connect that to a purpose, you get a transformation that allows students to experience their own power.

We believe in the idea of students' limitless capacity for developing and becoming special, caring people. That is inherent in the creative process and in the arts. It's a way of thinking and being in the world that allows us to connect that to "We can change this. We can definitely change this circumstance. We are not victims, we are powerful people who have limitless possibility and potential; we just need to harness it and do it together and we can make change." And I think that spirit comes from the creative process and having a school culture where people feel they have that possibility.

For instance, we've had a big issue in the community about the kind of air that we breathe, the contamination of the soil, and the impact that these have on our lives and health. Right now we're dealing with the serious issues of high asthma rates and cancer in our community. One of the ways that we are thinking about this relates to how to connect information about these issues to people in the community, especially to people who experience these problems.

Then there was the issue of Radiac, a nuclear storage dump in our community, and a proposal to site an even larger nuclear storage

facility nearby a block away from a public school. This was part of our concern about the health of people in our community.

And so it was young people who started that whole movement to oppose building this nuclear storage facility in Williamsburg. We created the "Toxic Avengers," who took information to the community in dramatic forms. The group of young people who came together and took action were actually part of a science class in our GED program, a program that gave young people final credits toward their diploma. The class went into the community and started doing some investigative research, which is when they happened upon Radiac; the building had a radioactive sign on it and they said "What is that?" They found out it was owned by Radiac Research and was highly charged with radioactive materials. That was galvanizing . . . the students were just so outraged when they heard about this that they started to say, "We've gotta let people know about this." But what was interesting was that many of those young Toxic Avengers were in theater and art classes at El Puente. They used what they learned there to get the word out to the community. They did guerrilla theater. They put signs in the community saying, "You are such-and-such feet away from this nuclear storage facility, and if there was an explosion, this is what would happen. . . ."

They did summer festivals and performed in the community. For a lot of these young people, this is how they got the word out, this is the vehicle and the venue that they used to be able to do public education, community education on the issue.

Another time I remember we had a big community rally against

the building of a fifty-five-story incinerator in the community. The image that everybody remembers of that was this amazing puppet that the muralistas, our art students, built that was a smokestack. They carried that puppet across the Williamsburg Bridge. The students were Latino, African American, and Hasidic. These young people led 1,700 community residents over the Williamsburg Bridge in a peaceful march and protest.

These are just some of the examples of the dramatic ways that young people in the arts use the arts and become involved in social movements and are able to fight for social justice. The arts both educated the community and bound students to their own community; the arts made them more fully citizens. This is something that I think resonates for many people here at El Puente. Traditionally— and certainly it happened to me growing up—the message we got was that the pathway to success was to get as far away from the community as possible, as far away from your roots as possible. There was nothing in the institutional experience of school that validated where we come from. Young people growing up in our communities feel disempowered and internalize oppression.

We started El Puente in defiance of a certain kind of educational thinking that is always about deficit; about the problems that our young people have because of poverty or because of who we are as people of color. And we defied that and said No, we're going to open up a space, we're going to grow an organization, an institution, a movement that really is about potential; it's about who we are and the resources and the potential that we have as a people. And so, for young people, it's not "Come to El Puente because you've got a

problem and we're gonna fix it." It's "Come to El Puente because you want to be something, become something. Come to El Puente with your dreams, whether that's to be a dancer or a painter or a lawyer or a doctor, whatever it is. Come to El Puente because you have a dream and you want to make that happen and we're here, the community, to say it can happen and we're going to support you to make it happen." And I think that's embedded in the experience of the arts and what it does for young people.

I think back to our first graduating class of fourteen. These were young people who would have been lost in the system; they had troubled histories in schools, truancy and all sorts of stuff, and a lot of those young people had dropped out.

Yet here at the academy they experienced something completely different. They were in a community that gave them meaning and that gave them a place in the world. They became clear about who they were and who they were in this community, and about what their purpose was in the world. I remember one young woman, who went on to Sarah Lawrence, saying, "I'm going to Sarah Lawrence because I think they need a strong Latina woman from El Puente on that campus." Now that was such an amazing statement from this one young woman, Jamie, because she came to us after pretty much flunking out of freshman year in another high school. She had come here with her cousin. He was in our after-school program and she found out we had a high school, and she wrote this compelling letter to me as the principal telling me why I needed to let her come to the El Puente Academy for Peace and Justice. I remember reading it and weeping. I said, "This young woman has to come here." I gave it to

the staff and everybody was on the verge of tears. Jamie came in and what I said to her was, "You're gonna come in and you're gonna come in as a sophomore. You're gonna make up those freshman credits and you're gonna graduate."

She not only graduated, she graduated top in her class and went on to Sarah Lawrence on a full scholarship. She was an artist. That young woman resonated with me. The idea of connectedness to your community, and the issues of making that community a well, wholesome place to live, a place where you can fly, is central to our vision.

At El Puente we fought to keep our arts program central to the entire learning program. That's against what has been happening in the New York City schools. There used to be Project Arts Funding in the New York City school system but it has been eliminated under the guise of school-based management, where principals are now being told, "You can take your budget, and you can use it whichever way you want." And we assume that you're going to go ahead and fund the arts. But there is all of this kind of insidious maneuvering that has resulted in the elimination of funding for the arts in the schools.

In the public schools now it's basically all about standardized testing, and mechanical literacy. This is resulting in dumbing down, watering down, the experience that young people have in school. It is equivalent to telling students that they are not to go deep within themselves and think in complex ways about things, but that they need to go back to memorizing and stuffing their heads with knowledge that has nothing to do with their experience and their world. This is not by accident; there is a reason this is happening, and why

it's happening in public schools and not in private schools and other places. This is an education for followers, not for leaders. And that's why I think a movement for change has to arise, and the arts are fundamental in this.

At El Puente we develop leaders who stand up and say, "This is the way we believe that good education and good human development needs to happen." And we have brought the parents in our community to the table; we have not, as others have done and do systematically now, taken community and parents away from the table and away from the decision making. You have to fight. And that's what we have done and are continuing to do.

We are a model of how the arts can be totally integrated into the curriculum. It can be the motivating factor in how you design curriculum, how you create an academic program for young people in which they understand the creative process and take what they are learning and use that in a creative way to make change in their community. This is really what education is all about. But that is not supported by the Board of Education. I do think that there are many educators who believe this is the way to go. And there are many parents and young people who believe this is the kind of school they would want to go to. And I think if we did create a way for those parents and those educators and those young people to come together, they would be a voice that could not be dismissed, particularly now when we are facing one of the greatest crises in terms of budget cuts. I think it's a time when we can feel totally disempowered, but I think it is a time when we need to gather the energy and find the inspiration and determination to go ahead and start making demands.

Otherwise, they will take everything of quality and value from public education.

If you build a school as a viable community institution where families come and bring their children, and they themselves engage in their own holistic development, and you start from the premise not of what they do not have but what they do have, and what their potential is and what their capacity is, and you say, "Give me your dreams and we will make those happen," not "Give me your problems and we will figure them out," I daresay that young people will rise and go way beyond expectations. They will create those expectations and own them for themselves, and in the middle of that is the creative process. In the middle of it is finding a space that is safe enough for them to go deep enough within themselves, into their souls, into their spirit, and say, "I want to understand my universe, I want to understand the universe. I have something to say, and I'm going to say it." And that is what is at the heart of the creative, artistic process, which happens in relationships, in a safe space where everyone is a teacher, and everyone is a learner.

That's what we have to fight for. It is an issue of justice.

Bill Ayers

A retired professor at the University of Illinois at Chicago College of Education, Bill Ayers is a writer and educational theorist. He is also a longtime political activist. His work focuses on urban school reform, the education of underserved students, and social justice in education. Among his many books are: The Good Preschool Teacher: Six Teachers Reflect on Their Lives; To Teach: The Journey of a Teacher; To Become a Teacher: Making a Difference in Children's Lives; A Kind and Just Parent; *and, recently,* To Teach: The Journey, in Comics.

High School Haiku

school—

take out the "sh"

and it's cool

Listening to Frances Lucerna talk about art and education, identity and memory, life's struggles and democracy's dreams is hearing the music that both soothes and energizes. Her voice, by turns harsh and exciting, honest and unruly, wild and straightforward, is powered by love and joy and justice, forever overflowing with life. I want to hear more. I want to play backup to that voice.

I'm reminded of Gwendolyn Brooks, winner of the Pulitzer Prize for poetry in the early 1950s and poet laureate of Illinois for many years, who asked in her "Dedication to Picasso," "Does man love art?" Her answer: "Man visits art but cringes. Art hurts. Art urges voyages."

Exactly. Art—which often begins in pain and horror, and when it's good, ends in the imaginable—embraces the entire territory of possibility. Art stands next to the world as such, the given or the received world, waving a colorful flag gesturing toward a world that should be, or a world that could be but is not yet. So if we believe that the world is perfect and in need of no improvement, or that the world is none of our business, or that we are at the end of history and that this is as good as it gets and that no repair is possible, then we must banish the arts, cuff and gag the artists—remember, they urge voyages.

If, on the other hand, we see ourselves as works in progress, catapulting through a vibrant history-in-the-making, and if we feel a responsibility to engage and participate, then the arts are our strongest ally. And, as is the case of El Puente, they clearly are the ally of young people, the challenge and hope that drives them to make history themselves.

Perhaps that's what Ferlinghetti was thinking when he published a slim volume with the provocative title *Poetry as Insurgent Art,* or what Picasso had in mind when he said, "Art is not chaste. Those ill-prepared should be allowed no contact with art. Art is dangerous. If it is chaste it is not art." Add to that Einstein's famous observation that "Imagination is more important than knowledge. For knowledge is limited to all we now know and understand, while imagination embraces the entire world, and all there ever will be to know and understand." Wow! The poet meets the most famous painter and the most renowned scientist of the century, and think about it: they are on the move and on the make, propulsive, dynamic, unsettled, and alive—of course.

The problematic life of engaging in the arts makes the passion for learning compelling: it is self-motivating. The connections between the arts and the community, between health in people's lives and artistic expression, as it works in El Puente, clarifies the arts as essential to a healthy, just, and caring life.

The arts illuminate some of the less visible and central dimensions of teaching, and the entire enterprise of education, from several different angles of regard:

- From the angle of four- or five-year-old children
- From the perspective of that ten- or fifteen-year-old kid on the corner
- From the standpoint of the human cargo on a train destined for the prison
- From the point of view of an adult world caught up in other matters, indifferent in part, and in other places guided by its theories and its standards, pursuing its well-intentioned, perhaps, but nonetheless blinding case studies—"condescension as self-pity"
- And then from the illumination and love that the creative life blesses us with.

Much of what we call schooling blinds us to perspective and process and point of view, locks us into well-lit prisons of linear ideas, forecloses or shuts down or walls us off from options and alternatives, and from anything resembling meaningful choice making. Much of schooling enacts a hollowed-out ethic and presents an unlovely aesthetic. When schooling is based on obedience and conformity it reminds us that these qualities and dispositions are the hallmarks of every authoritarian regime throughout history. When schooling suppresses the imagination, banishes the unpopular, squirms in the presence of the unorthodox, and hides the unpleasant, it becomes cowardly, dishonest, and immoral. When schooling segregates and excludes and isolates—whether along racial and ethnic lines or class backgrounds or ability—it fails as the deeply humanizing enterprise it might yet become. We lose, then, our capacity

for skepticism, irreverence, doubt, and imagination. When schooling is simply training, all the ingredients for forward motion are quashed and sacrificed.

While many teachers and students long for schooling as something transcendent and powerful, we find ourselves too-often locked in institutions that reduce learning to a mindless and irrelevant routine of drill and skill, and teaching to a kind of glorified clerking, passing along a curriculum of received wisdom and pre-digested (and mostly false) bits of information. This is disturbing in practice, and it is unworthy of our deepest dreams. That is where El Puente and its work is a countermodel, a guide to how education could be and how the imagination unfolds when the circumstances and the loving, patient, informed teaching of the adults create welcoming environments.

The dominant metaphor in education today posits schools as businesses, teachers as workers, students as products and commodities, and it leads rather simply to thinking that school closings and privatizing the public space are natural events, relentless standardized test-and-punish regimes sensible, zero tolerance a reasonable proxy for justice—this is what the true believers call "reform."

In this metaphoric straitjacket, school learning is a lot like boots or hammers; unlike boots and hammers, the value of which is inherently satisfying and directly understood, the value of school learning is elusive and indirect. Its value, we're assured, has been calculated elsewhere by wise and accomplished people, and these masters know better than anyone what's best for the kids and for the

world. "Take this medicine," students are told repeatedly, day after tedious day; "It's good for you." Refuse the bitter pill, and go stand in the corner—where all the other losers are assembled.

Schools for obedience and conformity are characterized by passivity and fatalism and infused with anti-intellectualism and irrelevance. They turn on the little technologies for control and normalization—the elaborate schemes for managing the mob, the knotted system of rules and discipline, the exhaustive machinery of schedules and clocks, the laborious programs of sorting the crowd into winners and losers through testing and punishing, grading, assessing, and judging, all of it adding up to a familiar cave, an intricately constructed hierarchy—everyone in a designated place and a place for every one. In the schools as they are, knowing and accepting one's pigeonhole on the towering and barren cliff becomes the only lesson one really needs.

If we hope to contribute to rescuing education from the tangle of its discontents, we must rearticulate and reignite—and try to live out in our daily lives—the basic proposition that all human beings are of incalculable value, and that life in a just and democratic society is geared toward and powered by a profoundly radical idea: the fullest development of all human beings—regardless of race or ethnicity, origin or background, ability or disability—is the necessary condition for the full development of each person; and, conversely, the fullest development of each is necessary for the full development of all. That is clearly the central premise of life and work at El Puente.

This core value and first principle has huge implications, of course, for educational policy: racial segregation is wrong, class

separation unjust, disparate funding immoral. But this principle has equally strong meaning for curriculum and teaching, for what is taught and how. It points in the first place to the importance of opposing the hidden curriculum of obedience and conformity in favor of foregrounding and teaching initiative, questioning, doubt, skepticism, courage, imagination, invention, and creativity. These are central and not peripheral to an adequate twenty-first-century education. These are the qualities we must find ways to model and nourish, encourage and defend in our communities and our classrooms. And these qualities are the precincts of the arts in their many incarnations.

4

"Good, Hard Work":

The Arts, Lifelong Commitments, Pleasures, and Pains

Bill T. Jones

*Bill T. Jones has not only invigorated the dance world but has chal-
lenged artists, citizens, and audiences to think, examine, analyze,
and act. His choreographic project* Still/Here, *inspired by cancer sur-
vivors with whom Mr. Jones worked closely, was the subject of a 1997
documentary by Bill Moyers and David Grubin entitled* Bill T. Jones:
Still/Here with Bill Moyers. *Continuing his tradition of challenging,
thought-provoking work, Mr. Jones more recently created* Fondly Do
We Hope . . . Fervently Do We Pray, *a dance piece about Abraham
Lincoln, his pivotal role in American history, and what might have
been different had his Reconstruction vision been realized. Mr. Jones,
a multitalented artist, choreographer, dancer, theater director, and
writer, has received major honors ranging from a 1994 MacArthur
"Genius Award" to Tony awards for his choreography for the Broad-
way shows* FELA! *and* Spring Awakening. *He has choreographed
and performed worldwide as a soloist and in a duet company with
his late partner, Arnie Zane, before forming the Bill T. Jones/Arnie*

Zane Dance Company in 1982. His memoir, Last Night on Earth, *was published in 1995.*

I remember when my mother tried to teach me my ABCs. It took me years to understand what had been going on. I think she had been taught very poorly. I think she had a lot of anxiety. We were very poor people. We were migrant workers. And I remember I had this beautiful little desk that had the letters A through Z, and a few numbers at the top. I had just started school, and I think that she was making every effort to help. She would sit and she would point and say "A" and I would repeat "A." And then she'd go back. And every time that I would make a mistake she would hit me, which is what I think she had been taught. I don't know.

She was a woman from the Deep South, with a sharecropper mother, and a father who had been chased away by a mob. There was a lot of violence in her life. I remember how wonderful it was to have her attention with those ABCs; there were twelve kids, and to have that attention was wonderful. And then, as it went on, it became horrifying, because at first I didn't want to disappoint her, but then I became terrified of being hit. So I remember getting through them all at one point crying. And as soon as she left, after she gave up—she was kind of exhausted as well after having ripped it out of me—I tried to do it on my own and I could not do it. And that was really devastating. That was the only time she tried, thank God. That was her method, I think: spare the rod and spoil the child. Now, this was a migrant-worker family of people and I think the stresses of

being in a primarily white community. . . . We were there to pick fruits and vegetables.

I was one of the first kids out of the twelve to actually go K through 12 in the same school. I started school in 1958. It was a time of a lot of optimism, just before the Camelot period of Kennedy. I benefited from that a great deal. The school got money from the federal government or the state government. I remember a new gymnasium. At one point they hired a drama teacher. We were in a rural community, as I said: German, Italian, and potato-growing community, and fruits and vegetables. The town near us was Naples, New York, if you can believe that. And there were a lot of good things going on. There was a swimming pool, so we were required to take swimming lessons. I remember first of all that the racial component was very important.

When we had to read out loud, I could not read as quickly, and there were students who could read ABCDEFG easily and I had to think about every letter. That's another story. There were some very patient teachers there. They were very well meaning. All the faculty were white people, women in their middle age. I remember Mrs. Shaw smelling of lilac sachet with her handkerchief. She would sit with her arthritic fingers and point out the letters to me. There was so much riding on my participation because it came just after *Brown v. Board of Education*. I was born in 1952. And here we were in the North. The white students were sitting with this young black child. Obviously I had something smart about me. They knew that. But I had a speech impediment. I had to have speech lessons and

there were these moments where they would be trying to encourage me. Sometimes I didn't understand why they would single me out, but there was so much riding on integration to succeed. That was the general atmosphere of my early childhood education.

Somewhere in this picture, in that flush time of money—it had to be sometime in the early 1960s; Kennedy might have been in the White House already—they hired a drama teacher whose name was Mary Lee Shafey. She was a self-professed (in this very conservative community) atheist. She wore miniskirts. She did not like television. She let us know she didn't like television. She said she didn't need anyone to tell her how to wash her toilet. She opposed all these things that were held sacred in our community—and I loved her. The greatest thing she ever said to me, when I was into my mode of acting out for my white classmates, was, "Cut the crap, Jones."

There was something shocking about it, but also accepting and strengthening about it. We had the kind of relationship that developed by the time I left high school where I would go down and sometimes just hang out with her. We would sit and talk. And she helped me process what was going on with the news in the churches in Selma, Alabama.

She asked me if I noticed anything different in the way that white people and black people behaved. And here I am talking with a white woman who has acknowledged the fact that I am different. She said that she thought there was something really different about the way white people and black people behave in church. And of course I knew this, but I had never talked with a white person about it. She

was teaching me, in other words. She was teaching me about self. And she gave me an opportunity to be in the drama club. There was no dance in my community. I heard that there were some tap dance classes in a town maybe fifteen, ten miles away. But my parents, after a day of working in the fields, were certainly not going to take me to tap dance classes or even, for that matter, to Boy Scouts or what have you.

But Mary Lee took me under her wing, and she was very tough with me, but she also encouraged me to get past my acting out and showing off, trying to entertain the class. She tried to get me to realize that I had to get skills. And she was able to critique me in ways that, when I think back on it, seemed harsh, but she was actually paying me the greatest compliment, which was to actually engage and challenge me.

By the time puberty rolled around and we were doing a production of *The Music Man* in the drama club, there was a problem, because I played the Buddy Hackett character. Because of the racial problems in our town, there was no way that I could have a girlfriend, being that there were no black girls. It was a mixed blessing. I was supposed to do a shoobadobee song while spinning a girl around. They wouldn't let that happen. I had to do it by myself. And there was no choreographer. I ended up improvising and brought the house down. The whole of my little small town rose to its feet at the end of my number, in the middle of the show, and were applauding and clapping wildly for my imitations of James Brown and everything that I had learned from dancing at home to the jukebox

and watching people carry on. I was putting it all together in an improvised dance number and I never had any dance training and I was dumbfounded at the applause.

I remember Mary Lee standing offstage suppressing a laugh. She knew what was happening, and in her usual firm way said, "Jones, get on with it." It was a wonderful moment, a triumph. Suddenly I had a new reputation other than being a smart-talking kid and a good runner. This kid is going to be in show business. I don't think anyone knew what modern dance was. Surely this of course meant Broadway and what have you. So that was Mary Lee Shafey. That's when I had a glimmer of what it might mean to be an artist.

It was treacherous water because there was great suspicion in my household toward white people. We were expected to speak one language when we were out with white people, and we were expected to speak another type of English when we were at home. One was "proper" English and the other was "be real" in your home. So, don't put on airs when you come into the house but you must put on airs when you go out into the world. Because this white community with its problems approved of what I did, did it somehow make me their patsy, their little trained monkey?

Did it somehow make me inauthentic? Was it, in fact, even though it was definitely a success, the ultimate humiliation? I felt that from some quarters, like from my father who was a very tolerant man. I loved him very much. He was a great storyteller and very comfortable with the white people he worked for. I remember him once saying to me in a cutting way when I didn't know what I had done: "You think you so smart. All you good for is entertaining white people." I

was probably a child twelve or thirteen years old. In other words, he was calling into question my authenticity.

When Mary Lee Shafey said "Jones, cut the crap," she and I had, I believe, an authentic relationship. But still, there was that uncertainty about authenticity. I was in an extremely buttoned-down situation, so self-expression had to be coded. I was allowed to be a performer. That was when I was allowed to express myself. And yet there still was this uncertainty in myself: "Was that the real me?" It was definitely a part of the "real me," but it came with this feeling of self-doubt and maybe even self-loathing.

I think it lives with me still. I think it explains my schizophrenic nature as an artist. Particularly when I was dancing (I'm not dancing as much now). I always joke and say that one of my secrets was knowing at what strategic moment to take my shirt off onstage. Seduction was something I learned early on. But with that seduction comes the feeling later on of, maybe, self-loathing.

I am much better now. I think that I have my accomplishments, and my dance company; with people I have loved and who really loved me I am not a shadow of myself. I think I have a greater understanding of myself as a man, but in my weaker moments I fall into old habits of doubt and self-loathing. Artists are always pushing against something. There's a good, healthy dose of ire and belligerence that has fueled me, as much as maybe the desire to be loved. So it's a very confused mixture.

Now, it's easier when I'm off the stage. When I was on the stage as a young dance performer, oftentimes performing for a predominantly white audience, there was a sense of anger and at the same time of

pride. But having succeeded, having a company get to twenty-five years, having had a partnership with Arnie Zane, a Jewish-Italian man who loved me and I loved him, I think that boy that I was describing has matured into a man. I don't know if he is well-shaped psychically but he is a man that I think I can approve of. Yes.

Kevin Truitt

Kevin Truitt is a former high school principal and is currently associate superintendent of student support services for the San Francisco Unified School District.

When I was teaching in south central Los Angeles at a very large middle school, we had a large auditorium that was solely used for the seasonal instrumental student music performances and the occasional guest speaker. More on this later. The school also had a special interest class at the end of the day where all teachers taught a unique class aimed at engaging students in a wider range of learning opportunities, enhancing the enjoyment level of school, and increasing the opportunities for teachers to better understand their students by seeing them in a different setting and allow for the building of stronger relationships.

The first several years of teaching, my special interest class was "math games" because I was teaching math. Then one day, I remember teaching class and one of my most enjoyable, spirited, and

animated students who needed a lot of attention was exercising a reward he had earned by briefly entertaining the class for the last five minutes on a Friday, somewhat like what Bill T. Jones did in his early schooling. Kids' attention was waning anyway and it ended the week on a lighter note. As he was delivering what I would describe as his own stand-up routine, I couldn't help but think that on a very real level, this kid was very talented. And this is coming from someone who has participated in countless improvisation programs over the years and attended quite a few comedy clubs. Based on my knowledge and experience, this young man had a very special gift, was uniquely talented. As far as I could determine, he had no outlet to even recognize or identify this talent, let alone develop and enhance it.

It hit me, as it probably hit Bill T. Jones's drama teacher, that I needed to direct a musical. Enough of these math games. You teach math all day long. You could actually produce a musical theater production during special interest period. I already had some experience in the theater and decided to plunge in. There are so many talented students with definite acting potential as evidenced by the drama in the hallways during passing period each and every hour of every day. It would also utilize our large auditorium in a new and special way—the way it was intended to be used. I could almost hear the auditorium thank me already!

I went on to produce and direct the school musical every year after my epiphany. The student I referred to earlier, yes, he was cast as one of the leads in the musical *Purlie* and he stole the show! Each year, they got better and better. Maybe because I was improving my

skills as a director, but also, the musical started to achieve the status as one of the most important events of the year and students felt a special sense of pride to be in the musical. Theater bonded our students together—not just the ones that performed, but the ones in the audience as well. We were all proud of what we could do as a school.

When I was a principal at Mission High in San Francisco, an English language arts teacher ran the drama program after school. When budget cuts forced me to cut staff according to seniority (you pick your battles), I lost that teacher and with her, our after-school drama program. The teacher was extremely talented. She had done such an amazing job with some very beautifully interpreted Shakespeare plays and discovered student talent I did not realize existed.

Naturally, those students were devastated that she was not returning. I waited over the summer for funding to be restored, but then she had to accept another job in another district. The students came to me pleading to ask another teacher to take up the after-school drama club so they could stage another production. Not wanting to let them down, and of course not strong enough to resist the temptation, I decided to take it on myself. As if the role of principal wasn't demanding enough, somehow I was going to commit to rehearsals every day after school. But the arts are so essential to the maintenance of school morale and spirit that there was no way I could resist. Besides, I like doing it.

I decided on Christopher Durang's *Baby with the Bathwater* because of its absurd comedy and because it was unlike anything the students had been exposed to. I am a very big Durang fan because of his perception and uniquely real yet bizarre interpretations of people

and real-life experiences. The best part of the entire experience was sharing my appreciation of his writing style with the students and watching them learn to appreciate a new artist. They were tremendous and I was so proud of them! It was a wonderful experience.

Now, as the associate superintendent of the San Francisco Unified School District, I wish I could take about six weeks of afternoons and devote them to another student production. I doubt it, but if I can find a way, I will. If nothing else, it is a great stress relief and wonderful to open the door for students like Bill T. Jones—just waiting for support and encouragement for the talent and intelligence they have. You get in touch with yourself and you develop a deeper level of understanding and more personal relationships with the students. For educators, there is nothing more important than the relationships we develop with our students.

Ask any adult today what they remember about high school and they will tell you about their relationships—their best friends, the favorite teachers, the events. Hopefully, they will remember the good times, the happy times, but unfortunately many of us remember the pain as if it were yesterday. The friends that betrayed us, the heartbreak, the times when we were embarrassed, ashamed, afraid, lonely, and sad.

Are the emotions of our high school students truly exaggerated or do they just get dulled over time? I am not sure. I do know that when you are hurt by someone in high school it can be traumatic. I personally know this feeling. Feeling as though the rest of your life is over. Everyone in the entire world knows your secret! Everyone on the planet hates you and you will be hated forever. You will never

love again and no one will ever love you. You are a worthless loser! I know that is over the top, but if you have ever sat across from a teenager who is in pain, that is how deep it is and that is what the mind is processing.

Teenagers live in superlatives! And they revel in participating in the arts and performance. Ask anyone who works with high school students and they will tell you that their emotional state is like a roller-coaster ride with intense highs and lows. Teenagers often describe the events and people in their lives with extremes. "This is the worst thing that ever happened to me in my entire life!" "I don't have even one friend that really cares about me." "I will never ever be in love like that again!"

I have personally witnessed students pushed to the edge and I have been very worried about their ability to handle the situation. I tell my students that I have a recurring nightmare that I will be retired sitting on a sofa somewhere watching Oprah Winfrey, and she will have a guest recounting the most painful memory in their life, and the person will say, "I was a student at Mission High School and let me tell you what happened that ruined my life." I will be devastated. In my seven years as principal of Mission High, I would have to say that my most consistent message to the students was to be nice to each other. Lead with kindness. There is enough pain and hurt in the world already, please do not create more.

So what does all of this have to do with arts education? The goals and priorities of high schools these days have changed over the years. We now recognize how critically important it is to develop personal relationships with the students. School communities are

creating structures to provide teachers and staff with increased opportunities to develop meaningful relationships with students. Teachers taking on the roles of "advisor" or "mentor" are very common in high schools. Students need guidance and support and need to know that if they are faced with a dilemma, they have a trusting adult they can turn to.

The vast array of art programs and classes that provide opportunities for personal expression for students are absolutely essential to helping students learn more about themselves and providing a venue for them to express their uniqueness and individuality. When students compose poetry and music, dance, paint, or portray a character in a play, they are engaging in a deeply personal exercise, and they are learning more about their personal beliefs and core values. When art is done well, it moves those who observe. When art is a true expression of the human experience, it provokes all who are exposed to it to evaluate their beliefs and develop their strengths.

I remember reading a quote from Bill T. Jones about his dance students: "I think that art making is a spiritual activity . . . I ask them for everything, I ask them for their innermost thoughts, I ask them for their sweat, I ask them for their creativity. . . . They have to understand that and make peace with it." I couldn't agree more. He supports the point I am trying to make. Art making is deeply personal and the process you go through is not easy; it is good, hard work.

Arts education programs in all mediums are opportunities to assist students in the process of defining their personal identities. Educators have recognized the critical and essential need to develop

deep personal relationships with our young people, who clearly need our guidance and support, not just in academics, but also in their personal lives. As school districts, especially in California, experience one of the most financially devastating periods in education to come along in decades, we must ensure that arts education has a prominent place in our children's educational experience. The lessons learned through arts education can have a much greater impact on the lives of our students and how they define themselves moving into adulthood than any biology or geometry skill.

I am confident in our upcoming generations and their ability to create a much better world. When I hear people disparagingly utter "Kids these days . . ." and imply that "kids these days" lack the skills and capacities of previous generations, I immediately and forcefully offer my disagreement and contradiction. With every graduating class that I saw "go into the world," I knew they had the capacity to make the world a better place. They are amazingly beautiful people and with personal support and guidance from educators in our schools, they will become the generation that we've been waiting and hoping for.

5

"Teaching on the Bandstand":

The Intergenerational Legacy of the Arts

David Amram

David Amram has composed more than one hundred orchestral and chamber music works and written many scores for Broadway theater and film, including the classic scores for the films Splendor in the Grass *and* The Manchurian Candidate; *two operas, including the groundbreaking Holocaust opera* The Final Ingredient; *and the score for the landmark 1959 documentary* Pull My Daisy, *narrated by novelist Jack Kerouac. He is also the author of three books:* Vibrations, *an autobiography;* Offbeat: Collaborating with Kerouac, *a memoir; and* Upbeat: Nine Lives of a Musical Cat.

A pioneer player of jazz French horn, he is also a virtuoso on piano, numerous flutes and whistles, percussion, and dozens of folkloric instruments. He has collaborated with Leonard Bernstein, who chose him as the New York Philharmonic's first composer-in-residence in 1966. One of Amram's most recent works, Giants of the Night, *is a flute concerto dedicated to the memory of Charlie Parker, Jack Kerouac, and Dizzy Gillespie, three American artists Amram knew and worked with. It was commissioned and premiered by flutist Sir James Galway.*

As a young student I was mostly either rebellious or questioning, what might be called these days hyperactive or attention deficit disordered. I always questioned authority when it didn't seem to make sense in my own context. Sometimes my own context was just about me and had nothing to do with the group situation and I should have just sat down and been quiet. But it wasn't always me. It's not even so much about being right and wrong as it is about being clear. The problem with the person who's telling you to sit down is that they should explain the whole social dynamic of why everyone, including you or me, has to do that.

Also, all of us would have to trust the person in authority in order to do what they say without questioning it. They would have to have a high level . . . a high moral, spiritual, educational, caring level to get compliance without questioning. Now that's a lot to expect of anybody. It is too easy to stigmatize the questioners. Schools should nurture creative and independent spirits rather than punish such kids and throw drugs at them.

Being born in 1930 and growing up where half the people I wrote about in my first book, *Vibration*, died from the use of drugs, I've never been a big fan of drugging out the entire culture. Which we do; we create a society of addicts and foster addiction in so many ways, but it's horrendous that it goes into the educational system.

I'm a music school dropout. I'm not proud of that because I wish I could go back and get a PhD from Manhattan School of Music, where I went and which I love. But I was so busy playing with Charles Mingus; he said, "Man, you'll learn more from me than you will from school." And I was studying with Charles Mills, a great composer,

and writing music, so I literally didn't have time. And what I did learn in those fundamentals at Manhattan School of Music I still use every day. So I wasn't self-taught; I was taught by every single person that I ran across. As a result, I can be good in a teaching situation, because I'm Mr. ADD—slow learner, dropout, impossible, with a tremendous respect for discipline and formality.

What our kids are losing in school is the idea that you can learn from anybody who has greater knowledge than you. There is an enormous amount of knowledge out there that might affect and transform your life, and you have to become a navigator and an explorer in that world, right?

We need to open pathways for the kids to what they never knew they might like. They're told what they should like rather than having this incredible opportunity to discover something, saying, "Hmm, that speaks to me."

I would try to give students events so that every student could participate in some kind of an event. Whether it be sports, theater, drama, a debating team, a sewing club, a language club, or a cooking group where they could cook their stuff and share it with the other students, where they could put on a little show for the other students.

I worked with Jacques d'Amboise, who does this wonderful program for the National Dance Institute. He got blasted by all the ballet critics because he was one of the world's greatest classical dancers and they looked at his shows and said, "This is nothing but kids as if they were doing gymnastic exercises." Jacques said, "I can't expect them to dance like I did." He said, "I spent my whole life doing that, and I'm one out of ten thousand that was able to do it and work with

Balanchine. So if I did that, it would be fine, but there are already hundreds of schools doing that—looking for one Olympic gold medal winner and everyone else goes home a loser." That's not exactly what he said, but that's what he indicated. His idea was to give every single kid an opportunity to be in a show, to be in something. To have their families come and see their kid, and be with their schoolmates and other people from other disciplines, a chance to do something together, just to have that experience. And it was extraordinary, and it transcended the idea of what's supposed to be an artistic ballet, and a lot of it was very artistic, but it was geared with the idea that everybody was supposed to be able to be somebody and to help defray that horrible thing that kids are told, which is, "You can't, you can't do that. You're not capable of that, that's not for you."

One of the greatest, most touching things in the *Autobiography of Malcolm X* was when he was told, "No, you can't do that; black kids can't do that." When Louis Farrakhan, who's an excellent classical violinist, was told by all of his teachers, No, you can't do that, I think that's one of the reasons he became so enraged against most society, because he was told that because of his race he couldn't do it, even though he was already doing it. And way before I ever read Malcolm X's autobiography, I told my teacher what I wanted to do and I was told, in an affectionate way, a Jewish boy couldn't do that. This is something that affects everybody, *everybody*, in some way. People are told that they can be socially undesirable. This is what has to be negated in the schools, especially through the integrative power of the arts.

When I was a composer in residence at the New York Phil-

harmonic, a descendant of one of New York's oldest society, old-money, Mayflower-descendant families said, "Well, it's so marvelous, Mr. Amram, that you can do all these different things in music." He said, "Our kind of people, my family, we're just not capable of that, we just don't have that within us." He wasn't saying that to say, "You miserable immigrant scum are the ones who can sing and dance." He meant that "Unfortunately people of my wonderful background just don't have music in them; we can be great stockbrokers and lawyers, and we'll support the arts and we love it, we love our culture, we love our country; we're just not the types of people that can do that kind of thing."

Then I go to a folk festival in Canada and see these folk groups from England playing up a storm and wailing. And I said, "My gosh! I never knew that there was any English folkloric music like that." And they came from the same place as the people who came from the Mayflower, the same part of England. And they said, "Oh no. We're just a fraction. You've gotta come over there and get way out in the country and hear what we do, hear our drummers and how we play and dance."

So everybody has all of these things in them, but we're all told in our society you can just put on the right fender. But as a result of that, you can't even know that there is a left fender, or a carburetor or a highway for that car to drive on. So that's the biggest problem. We're so great at specializing, which is good—you have to be able to pay your rent and do something well. But above and beyond that, you can be part of something that you might not do to be professional but which can enrich your whole life.

That's my long-winded way of saying that we should open up the doors for everybody to feel they can be at home in the arts and be interested in everything else. And that's my whole message when I go to all these schools and go to these different departments, when they say, "What the heck is a composer, conductor, multi-instrumentalist playing all these different kinds of music for? He must be a schizophrenic, or he has a multiple personality disorder, because he's going to all of these different areas."

It's not that I'm a biologist, anthropologist, or historian, but that I have an interest in all those things. And my hope is that maybe a law student and a trombone player who are in the same building for four years, or the same dorm, will hang out with one another for a few moments, maybe a few hours, and share information, and educate one another to the extent that, when they leave school, they can continue their lifetime education of being a student and a teacher every day.

When kids who do have talents are not allowed to express them because of the way learning is structured in school, it's like taking someone with an appetite and telling them that they have to miss a meal. If you punish someone that much, they say, "Boy, I'm getting hungry," but it's hard if you never have a chance to feast. To stop somebody from trying to play an instrument or to act or to write a poem or to paint is like denying somebody breathing or eating.

Telling somebody "No you can't, don't do that. You're wasting your time, you're not talented enough, you'll never make it. You have to spend your time learning to pass the test" before they even have a chance to begin is the same thing that we do when babies are crying

and you just scream and tell them to shut up. That doesn't help the baby and it doesn't help you. In school, we need the patience of a parent, to let students learn to try things out, to experiment and fail and get to know their own skills, talents, and desires. We need to give them an opportunity to try things out, including and especially the arts.

I understand what growing up in a ghetto community is like. In retrospect, that was a precious situation to be in, to understand what life is about, and to have respect for every person whose path you cross. It wasn't only in Washington when it was segregated, where we were living in what they called a checkerboard neighborhood, a black-and-white neighborhood, but it was also on the farm before I was in Washington, during the Depression; we were the only Jewish family, and I was the equivalent of what the black kids were like in many parts of the South and the North—the minority that got beaten up, not because of anything personal but just because of my name and who I was.

It gave me an understanding that a lot of those kids who attacked me—some of whom weren't really that way—were hurting, too, and they were suffering, too. That gave me the blessing that, later on in life, I could understand that I was basically no different than any other person whose path I crossed and neither was anybody else. That's why I love playing with Willie Nelson today, and I loved playing with Dizzy Gillespie, and I loved being with the New York Metropolitan Orchestra and Bernstein. The people I mentioned all came from different backgrounds, but they all had that human thing where they never snubbed any person, not because they thought that

was politically correct, but because they realized that every person is precious in some way. That should be the message young people take away from school. And what better way than through the arts?

I wrote a piece for the Philadelphia orchestra called *Trail of Beauty*, based on the Navajo prayer: "Walk in beauty . . . beauty all around me . . . beauty above me . . . beauty below me . . . on the trail with beauty . . . therefore I am." The commonplace, the everyday is of the utmost importance. Paying attention, taking the little things in life, treasuring them and learning how to put things together is essential. That's how I relate to the world, to my children, to the arts.

Gary Stager

Gary Stager is the executive director of the Constructivist Consortium. Since 1982, he has helped learners throughout the world embrace the power of computers as intellectual laboratories and vehicles for self-expression. He led professional development in the world's first "laptop schools" in the early 1990s, was a collaborator in the MIT Media Lab's Future of Learning Group, and was a member of the One Laptop Per Child Foundation's Learning Team.

Converge magazine named him a "shaper of our future and inventor of our destiny." The National School Boards Association recognized Dr. Stager as one of "20 Leaders to Watch," and Tech & Learning magazine named him "one of today's leaders who are changing the landscape of edtech through innovation and leadership."

Gary Stager was the new-media producer for the Brian Lynch/ Eddie Palmieri Project's Simpático, the 2007 Grammy Award Winner for Best Latin Jazz Album of the Year. He is also a contributor to the Huffington Post.

David Amram is correct in reminding us how music making may be an antidote to the curious epidemic of learning disabilities "plaguing" young people. Children have a remarkable capacity for intensity, which, when channeled in challenging directions, may lead to greatness. When ignored or suppressed by twelve years of joyless compliance in cheap plastic chairs, antisocial behavior or detachment are predictable outcomes.

Wherever I go, I am alarmed by the societal implications of a generation of American teenagers who have never had a conversation with an adult. Sure, they may have been called names or told what to do—ranked, sorted, and labeled—but they've never fixed a car with a neighbor, gone fishing with an uncle, or studied the cello with a musician.

Like team sports, playing music allows you to be part of something larger than yourself. However, music offers so much more than teamwork or apprenticeship experiences. Musicians strive for beauty and aspire to contribute to a cultural continuum across generations and in defiance of age or physical limitations. When a child sings or plays an instrument, they join a community of practice, complete with intergenerational expertise, common objectives, individual pursuit of excellence, a celebration of tradition, and an eye toward legacy.

Recently, on the occasion of my high school band director's retirement after forty years of teaching, two friends and I took him and our high school jazz teacher to New York City for an evening of jazz, food, and laughter. We wanted to say "Thank you" to two men who contributed greatly to our development. They not only taught

us how to play jazz and classical music but what it meant to be a musician and a man. Through music, they taught us poise, humor, work ethic, and our nation's tortured racial history. They helped us fall in love with an art form and its artists in a way that contrives to enrich our lives. They taught us to swing and to listen. Although they were adults and we were teenagers—teachers and students—we were colleagues in music.

Several years ago, I attended a gala at which the National Endowment for the Arts recognizes half a dozen brilliant musicians as Jazz Masters. A thousand or so VIPs, professional musicians, music students, and teachers were in the audience, joined by several dozen of the greatest musicians America has ever produced—previously inducted Jazz Masters. Moving tributes were accompanied by performances from an all-star big band. The traditional grand finale invites the "Masters" onstage to play blues with the band. Jazz greats Chick Corea, Slide Hampton, Paquito D'Rivera, and Jimmy Heath took the stage for an old-time raise-the-roof jam session.

Suddenly, I noticed a four-foot-high kid in camouflage shirt and cargo pants wielding a trumpet and hurling himself onto the stage. The great trumpeter Jon Faddis did a double take while conducting the band and asked the child standing next to him, "Hey, are you a Jazz Master?" Tyler replied, "What key is this in?" Still thinking he was being punk'd, Faddis nodded toward the kid at the end of the masters' solo. Tyler then improvised a bunch of choruses, perhaps too many, to an ecstatic crowd. When you're on the bandstand, you play.

When the song ended, all of the musicians, including Tyler, took

a bow. Jimmy Heath, a musical legend eight times Tyler's age, put his arm around the kid and proudly shared the applause. That is because the young trumpeter was willing to imitate the behaviors of the experts, and the master musicians were pleased to share the bandstand with someone who might continue their tradition. This is not the case in the average Algebra II class.

Such generosity of spirit, selflessness, and "teaching on the bandstand" occurs wherever musicians gather. Their artistry requires a self-awareness and reflective ability that make them great teachers. Musicians offer these and so many other lessons that could and perhaps should inform the teaching of all subjects. Playing music requires the self-regulation, purpose, and discipline that serve as the cure for much of the hyperactivity, ADD/ADHD, and other ills afflicting schoolchildren.

6

"Walking into the Fire":

The Arts as an Integrative Force in Learning

Philip Seymour Hoffman

Philip Seymour Hoffman is one of the world's most recognizable character actors. He studied acting at New York University's Tisch School of the Arts and received his BFA in drama in 1989. On Broadway Mr. Hoffman received Tony nominations for his work in Sam Shepard's True West *and Eugene O'Neill's* Long Day's Journey into Night. *Highlights of his stage work include Jane Anderson's* Defying Gravity *at The American Place Theatre, and* The Merchant of Venice *directed by Peter Sellars. Hoffman has also distinguished himself as a director with Off-Broadway projects such as Rebecca Gilman's* Glory of Living, *Stephen Adly Guirgis's* Jesus Hopped the A Train, *and* The Last Days of Judas Iscariot. *Film credits include Joel Schumacher's* Flawless, *Paul Thomas Anderson's* Boogie Nights *and* Magnolia, *Anthony Minghella's* The Talented Mr. Ripley, *as well as* Capote, Almost Famous, Happiness, Patch Adams, *and* The Big Lebowski.

I was introduced to the arts by my mother in a way, but I remember, while I was in grammar school, being in a production of *Tom Sawyer.*

I remember they did those types of things in grammar school, and I also remember auditioning to be in the band, and I remember that you had to take a musical test and I did well on it and ended up training to play the clarinet and then the bass clarinet. I was also in the choir. Doing those things were my introduction into some kind of arts existence.

There's a sacrifice made when you're taking part in the performing arts. As a young child, I remember when I had to perform *Tom Sawyer*, being very sick with nerves and then going out and doing it anyway and then feeling the release of that. It required concentration and walking into the fire with my fear. I remember feeling all those things and I was only in fourth or fifth grade in a rural suburban area outside Rochester, New York.

I remember experiencing that, and not wanting to play the instruments anymore because I realized it was a lot of responsibility. Playing an instrument and playing music was a huge discipline that I wasn't ready to take part in, so I didn't. I remember quitting, and I remember that as being one of the hardest things I had to do.

In junior high I was very involved in sports. Then in high school I got involved in the theater program that was quite developed. I remember playing Willy Loman in *Death of a Salesman* when I was a senior in high school in front of six hundred juniors. Partway through rehearsals I had to go to New York to audition for NYU, and I got to see Dustin Hoffman play Willy.

It was a matinee, and I remember there was only one seat left, and it was one of the box seats, so I sat with a party of three, and I remember how they talked with me about the play afterward. And I talked

about it when I went home. The theater does do that. It did it to me, and does it to a lot of people who aren't in the theater. It makes you want to go back to school the next morning and share your experience, because on a very base level, it creates a community that you are a part of, that you take part in, and share in. It shows what a community means, what it means to be next to people and have relationships with people or share a society with people. That's what theater does. It's one of the many things that theater is here for, and why it will never go away, no matter how technologically advanced we get.

I remember going back home and stealing from Dustin Hoffman all of his ideas, emotionally, about the play. I wanted to soak up everything, and performed in a kind of crude, impassioned way. And I remember six hundred sixteen-year-olds watching the play, and it was amazing. I also remember being at a party three weeks later. Everyone was s—faced (it was one of those teenage beer-drinking parties) and this kid comes up to me, he was my age, and he says, "You know, man, I came there to see the play and had my Walkman and my headphones. Then the play started, and I never put them on."

As he was talking to me he was looking at me in a way he never looked at me before. And I remember seeing these students afterward and they all dealt with me differently than they had before. There was something about my commitment, about watching that kind of play, and seeing what theater can do, that had a very strong impact on those kids, and it was a very special day.

I was shown a pretty healthy theatrical life in public school. A few of my teachers approached their work from a very creative standpoint, and were very supportive of the interest I was taking in the

theater itself at that time, and so I did thrive more educationally in high school because of it. When I got involved with the theater, there were teachers that I started connecting to on a much more cultural, artistic level through my enthusiasm for theater. My whole academic performance went up in high school. I associate that in part with my enthusiasm for school in general, because of what I was doing in the theater.

My mom took me to the theater when I was eleven or twelve. The first professional play I saw was *All My Sons,* and I remember sitting in the front row. I saw a lot of new plays, because the regional house, the Geneva Theatre in Rochester, at that time would bring in actors from New York. I saw a lot of exciting plays from a very young age. I got a lot of support. My mom loved the idea of me being involved in the theater, and loved the idea of me loving sports—she was a big sports fan—and so it was kind of okay for me to go back to sports, and it was okay, you know, to be a theater person who also liked to watch baseball. That was cool.

The summer between my junior and senior year, I got accepted to a program at the New York State Summer School of the Arts. The Circle Repertory Company was the company they hired to run this summer program for high school kids, and they'd pick thirty-two high school kids from all over New York State to go to this program at Circle Rep. I auditioned in Rochester and New York City and I got picked. That summer had a lot to do with my decision to study theater in college. I still didn't know that I would have a career, but probably at the end of my tenure in college I started to think it was the only thing I wanted to do.

Theater is part of an education that embodies the notion of a just and equitable society. If you don't experience empathy and compassion and catharsis in some way, if you don't learn about that and cultivate that, something is lacking in your life. I think that you have to learn about justice and compassion, and cultivate it. The main area to do that is through the arts and that is something that helps with equality, absolutely.

Whether it's through reading, through fiction, through film, theater, painting, writing, you know . . . all these things should be a part of the curriculum along with math, science, or anything else—and that includes sports. They should all be integrated. They all have to do with each other, because that is what life is like; everything has to do with something else, and nothing is separated. Compartmentalization just doesn't exist, it's not the way life works. Education has to be structured to understand this: that is the way creative minds can be developed.

All the arts can be incorporated into all the maths and sciences, and they can be one. I think that a school doesn't have to literally work that way, even though it would be better if it did, but that all the arts should be taught alongside the maths and sciences, as something equal to, not less than. That's what I would want for my kids.

I think that the public school that my son is attending now is doing that in some ways. I see a very creative mind-set in the room. I see what he brings home, I see how he is. But my kid is lucky. Because he's my kid and he travels with me, walks into many theaters he won't even remember, he understands acting. We talk about plays and performances. He understands that life innately, and that it is a

part of life that shouldn't be something that is separated or special—that's just a part of life.

I don't think you can force someone to be interested in a certain art form. I didn't end up playing the clarinet, or singing either, even though I wanted to stop playing the clarinet so that I could sing. I ended up acting, which is probably the scariest of the three to me. I ended up acting because my mom took me to the theater and that's something I fell in love with.

That's going to happen to you whether you like it or not, and that's going to happen to my son and my daughters whether I like it or not. I mean, I sit here and I fantasize about my son being a painter. I fantasize about him being something other than an actor, but he might torture me with the fact that he wants to become an actor, and that's the way it's going to be.

I want to introduce him to and let him experience all the art forms, as a part of society and a part of his life. He'll take from that what he will. But I also love sports. I also like to utilize creative energy and creative talk through sports with him, so maybe he'll do something with that, and that would be cool. Along the way I've got to accept it where he'll go. Besides, the creativity and effort are one and the same thing.

Even when you get out of school and get out into the world, they want to separate the film actor from the theater actor. They want to separate the playwright from the screenwriter, they want to separate the novelist from the poet, or separate the scientist from the businessman. They don't want you to be anything except one thing. They want you to be what they want you to be. It's illogical. A creative

mind goes where it wants to go. When you're young you're told, "Well, this is who you are, who you have to be." Well, that can't just be who I am; it can't be the only thing. A lot of people will believe that, and they'll spend their lives thinking they're only one thing.

When I was young, I read *A Dream of Passion* by Lee Strasberg. That book is about not calling yourself an actor but calling yourself an artist, so you're not choosing to be identified as an actor but to be identified as an artist. There's a difference. I remember that opened my eyes a lot. This is all for the taking, you know. I'm trying to create something in my life. I don't know what that will be, but I'm trying to create something, and that might be through a play and acting in it, maybe it'll be through directing it, maybe it'll be through producing. I'll direct a film, maybe I'll act in a film, maybe I'll help develop some play with a writer. This sense of possibility is not encouraged enough in education, no matter what you decide to do with your life.

I would like society to be free to explore all avenues. I would like that message to be part of education. It should not be fear based and convey the message "No, no, that's your niche, that's what you're going to do, that's what you did successfully, so you should do that."

I started learning in a much quicker way, by absorbing things in a fuller, quicker way, when I started understanding myself more as an artist and less as an actor. I started looking at myself through an artist's eyes. Everything became more interesting, because everything became part of how I'm going to create something.

I'm on the board of a public school in the Bronx. It's from sixth grade and up, and everything in the curriculum is influenced by the arts. They've been around for over ten years, and they deal with

kids of the lower-income areas of the Bronx. I joined up with them through my theater company, Labyrinth. They've taken part in Labyrinth shows. I've been helping them raise money and working with them for the past ten years. They have been honing and perfecting what it means to make the arts pervasive in the curriculum. What does that mean, to bring arts into the math class? What does that mean, to bring arts into the history class?

If we want to help nurture people to think in creative ways and show they can be artistically creative with their logic about almost anything, we need to figure out the best way to do that and still not lose the quality of academic learning.

Part of what school is to me is about being with other kids. A very important part of being in school is not just sitting and listening. They have to do that sometimes, obviously, because they have to be instructed. But having a group of kids who begin to move and play in space with their bodies together, and who know how to learn together, is very important for the quality of learning.

I go to my kid's school a lot. I watch them interact, I watch them do what they do, and what I'm seeing in my boy is that the relationships with the other students are huge. Interacting with peers is everything. Children learn as much from their peers and their friendships as from what their teachers are telling them. There needs to be encouragement for these relationships and time made for them to develop. The arts facilitate this.

The question is how schools can nurture the kind of discussion and talk and interaction that is optimal. It shouldn't be controlled, but should be free and open and expressive. And so how do you

instigate it in such a way that it leads toward something that's more beneficial for complex learning?

I think that if you don't instill in your kids that what they're doing is special and exciting and worthwhile, then you're going to lose them. I know that as a director, when I direct plays, I know that if I don't instill in my company that it matters, that what they're doing matters, and that what they're doing is special, then I'll lose them. And I think it's the same thing with kids in school. The minute they think that school's a drag, that school is where you just come and get through it, where you try to pick up girls, or do drugs, or whatever it is, you've lost learning and growing.

Deborah Meier

Deborah Meier is a senior scholar at the Steinhardt School of Education at New York University. She has spent more than four decades working in public education as a teacher, writer, and public advocate. She was the founder and teacher-director of a network of highly successful public elementary schools in East Harlem. In 1985 she founded Central Park East Secondary School, a New York City public high school in which more than 90 percent of the entering students went on to college.

From 1997 to 2005 she was the founder and principal of the Mission Hill School, a K–8 Boston public pilot school serving children in the Roxbury community. The schools she helped create serve predominantly low-income African American and Latino students, and are considered exemplars of progressive reform nationally. A learning theorist, she encourages new approaches that enhance democracy and equity in public education. She was a recipient of the prestigious MacArthur Fellowship in 1987.

Among her books are The Power of Their Ideas; Will Standards

Save Public Education?; In Schools We Trust; *and her latest,* Playing for Keeps, *with Brenda Engel and Beth Taylor.*

The arts are central to a good education. Not as occupational training, but because we're human beings. The arts are not an add-on, something invented by "civilization." In fact, our oldest languages were probably the arts—drawing, signaling, dancing, making music. Speech itself is a form of art, and the storyteller long precedes the novelist as an artist. The storyteller precedes the historian, too. And night-sky watching was a form of aesthetics before it became an entry into science.

To abandon the centrality of the arts is to abandon our core of humanness, and in the long run to undermine all the "disciplines" that the modern school has focused on as it pushes art further and further to the margins.

It's not a fact that history and science are "noncreative" disciplines, that they are outside the realm of the "creative arts." In fact, at the University of Chicago, my alma mater, history belonged in two different disciplines: either the humanities or the social sciences. Foolishly, one had to choose. I chose without a second thought to major in history as a field of the humanities.

Similarly, I bristled when courses in "creative writing" were defined as strictly fictional writing versus writing about the "factual world." It was as though we could divide the world so neatly. What kind of writing would aspire to being "noncreative"? What great history book or science book didn't speak to our imaginations, and didn't reach us through its capacity to re-create the world in a

new way for us, to help us resee and rehear both the ordinary and extraordinary?

In part, I think Philip Seymour Hoffman accepts this division of labor a bit too easily. He falls into the habit of speaking of creativity as linked to the arts in ways that play into this dichotomy between the soft/creative disciplines and the hard/scientific ones.

This is hardly surprising given that over the past century we have steadily undermined the historian as storyteller, scientist as explorer, mathematician as a seeker for pattern making. Thus it seems artificial to suggest that "playing" is as important to the "hard" disciplines as the "soft" ones. The playfulness of childhood has eroded in part by our dismissing it as a luxury, a creative—i.e., subjective—field, hardly even a "discipline." If it can't be objectively tested or measured on a standardized scale, and deemed essential to our national and economic competitive edge as well, it can be set aside for "later." Maybe it will be useful for our idle retirement years?

I thought of how Hoffman's experience going on the stage as Tom Sawyer was like mine. I was on the stage just last week to talk about schooling! I was sick with nerves, and once I got going, felt the release. In both cases we were setting out to influence in some way an audience by reaching across through language to what we shared of life experience. Of course, there are differences between the arts themselves, and it's easier for me to see the commonality between my fascination with history and Hoffman's with drama than it is for me to understand the arts of music or the visual arts. Yet I suspect that if I were wiser and more competent, I could see in even the most

abstract of arts the essential ingredient that makes us human—our search for ways to communicate what is deeply felt and what inspires our imaginative free play. After all, when I hear good music (the stuff I like), it creates feelings that weren't there a moment before.

We are players all. Play is not just the way little children make sense of the world: it is our human way. It transforms our range of possibilities, just as it did for those youngsters who "all dealt with me differently than they had before" they had seen Hoffman "onstage."

I regret in many ways that small schools have led us so often to eliminate the rich arts programs that the larger public schools of my youth took for granted. I understand why it might be, but it wouldn't be so damaging if we hadn't simultaneously accepted a false definition of the arts. If we hadn't separated "creativity" and "imagination" from the "hard" disciplines, then the trade-offs would appear less damaging. As a child I foolishly dismissed mathematics as a serious subject for serious people precisely because I thought it a rote, right-answer discipline where creativity didn't matter.

My brief interest in mathematics as something else coincided with my becoming a teacher and fortunately captured my fancy and that of the children I taught. Its failure to "prove" itself on standardized tests and its novelty to both parents and teachers gave my interest a short life. Today's math reforms consist of either a return to "The Facts," or wordy efforts to emphasize its practical uses.

Relevance—an important concept—has been defined in school talk as application to daily tasks. Aside from the silliness of this demand for immediate practicality, it fails to tackle the deeper

meaning of relevance, which includes our "as if," "supposing that" imaginations. Adult playfulness is critical to our future and is at the heart of the academic disciplines if we ever dig deeply enough.

The playfulness of childhood itself has been eroded by our narrow focus on a form of "academia" that has abandoned its roots in the arts, that has removed from subject matter everything that can't be tested and measured on an "objective" and "standardized" scale.

Think of all the theater and literature and music or other arts that couldn't find an audience but appear to us now as "classics." So too are the sciences and histories that now seem correct that would at one time have appeared fanciful and absurd.

I discovered this early on, in my first few years as a kindergarten teacher. Following a standard Board of Ed curriculum guide, I introduced the Big Idea: distinguishing living and nonliving. I had a simple three-day plan—right out of the book. Each child was asked to bring in an object so we could place them in either the box marked Living or the one marked Nonliving—and come to an appropriate conclusion.

Day One: Darryl insisted that his rock was alive. He was drawing upon his own powerful experience and creating a story that was so convincing to him and the rest of us that I gave up for a while on pursuing that particular approach to "living and nonliving" things. (It didn't help that the next child to present was holding a leaf she had torn from a nearby tree.)

Day Two: I informed them that the distinction between living and nonliving was on the cutting edge of science and that we'd continue to explore it all year long.

When six-year-olds are playing in the school yard, their conversations are both imaginary, creative drama and a "scientific" reconstruction of reality as they know it. They are playing with reality, turning it upside down and inside out, in order to better understand it. Virtually every one of the "habits of mind" that we "invented" at Central Park East for defining what it meant to use one's mind involves a form of play—seeking patterns, wondering "what if," and "supposing that," or "who sez so?" These basic intellectual "habits of mind" are part of the way we lived at the schools I created within the New York and Boston public school systems. Whether resolving a playground fight or resolving a mathematical equation, these questions fit right in.

Can we quash that part of our humanity—the early artist—without paying a price? Probably not. But fortunately, it's hard to do. Even the child deprived of explicit time and space for play finds ways to play inside his head, at night under the covers, or in the woods away from the constraints of civilization, or turns everyday tasks into a form of secret play. But divorced from the world of others, such play is deprived of important nourishment and fails to grow to its potential. Schools can be a place for the sharing of play and expanding its domain. It's why recess can be such a rich source of creativity—as groups of children reinvent worlds day after day, varying realities from day to day.

"I have an idea!" is heard too rarely in classrooms and constantly in the playground, where children invent scary stories, fairy-tale families, fantasy adventures, death rituals, and on and on.

Democracy, that absurd form of life we've chosen to dedicate

ourselves to, is particularly dependent on the flourishing of such play—the capacity to pretend otherwise, to imagine a tomorrow that's not like today, and to sympathetically step, even briefly, into the shoes of others. Doubt is not a weakness, and doubts about democracy are not treason. Rather, they are the sources for going a step further, exploring more deeply, listening more attentively, and imagining: could it be?

Philip Seymour Hoffman is right again, that the social life of school is central to the arts, where such sociability does not become a vehicle for shaping us to conform to a single ranking order. Schools for young children need to beware of how easy it is to turn the social life of schools into a subtle or not-so-subtle set of ranked cliques that frame us forever.

And finally, as Hoffman notes, the arts in this broad sense are a source of continual renewal for us. We know it matters when we sing a song or act in a play or make up a story—we don't need to be told why it's relevant. The creative life may get us into trouble, as Hoffman notes, but it should not be our teachers who instill that fear.

I have often noticed that when the three P.M. bell rings across the nation, children of all ages come bounding out of school with hearts and souls ready for adventure. Their enthusiasm for the hours after school is intact. But half an hour or so later, the teachers come dragging out, exhausted. I'll settle for the time when they both come out enthusiastic to pursue and continue the work they did that day on their "own" time. That will be the day when the arts have come to school in the fullest sense.

"I Taste It When I Look at It":

The Importance of Arts for Those Who Learn Differently

Whoopi Goldberg

Whoopi Goldberg is an American treasure. Hailing from the housing projects of New York City, Ms. Goldberg has made myriad contributions to culture. Her landmark performances include the films Ghost, Star Trek, Sister Act *and her Academy Award–nominated portrayal of Celie in* The Color Purple. *She is also a voice of social engagement and of action. Ms. Goldberg's social causes include her early work with HBO's Comic Relief, which originally raised money for charities that worked with African famine, and which most recently raised money for victims of Hurricane Katrina. Ms. Goldberg has also been an advocate for UNICEF, women's rights, equal rights for LGBT people, and global human rights, and has participated in important UN discussions. She serves as an advisory board member for the Stella Adler Studio's Outreach Division. As a producer, she has enabled the creation of important work including the 2003 Broadway revival of* Ma Rainey's Black Bottom.

I grew up in a world with music and art and going to museums; it was part of my experience as a young kid. So I can't imagine what it must be like to be in a world where that's not available to you. I think it's detrimental . . . it makes for idle hands and I'd rather see young people being creative than being mischievous.

I went to a Catholic elementary school, so there weren't a lot of different kinds of music, but I grew up in an environment in Chelsea and in my mother's house that said that there was nothing not within reach. My mom is a Head Start teacher, and I am one of those kids who did not go to high school because it held no interest for me. She understood that; it didn't scare her. But in those days you could go to different places around the city and get credit for stuff. You could go to the Natural History Museum, and as long as you kept track of what you were doing, you were in pretty good shape with the educational authorities. Also, you know, it was a great time here in New York, at least for me, because everything was happening. The world was changing, literally, as we sat and watched Columbia (in the mid-1960s) go through its machinations. We saw the Yuppies downtown on the floor of Wall Street. It was an extraordinary time, and I lucked out to have been disinterested in most things except the arts.

My mom never limited what I could do and, in fact, made sure that I recognized there were lots of possibilities. She carried hope forward and instilled that in my brother and in myself. And I think sometimes about those old stories that you shouldn't waste time with the arts, or if you do, you should get a job that you can fall back on, or you'll never make it in life. Those conversations still exist. For

children of color, this is slowly, slowly changing. The idea that you can be an actor, that you can be a dancer, is beginning to change, and—I hate to say this—but part of that is because of things like *American Idol* and *America's Got Talent*. I hate to admit it, but one of the things that kids are seeing on the television is that it could be them up there, so they're getting it, in spite of all the things that are being put up to block them.

The reason I bring up *American Idol* is that my grandson is ten and only loves hip-hop music; that's his thing. He plays basketball, he loves hip-hop music. Somehow, some piece came on *American Idol* that the Beatles did and it just went whoosh. He went, "Who are they?" And I played some stuff for him, and he was like, "Wow, this is really interesting!" I said, "I can play some more stuff for you." So I began to play different sounds, different pieces of music and he wants more and more. I understand that music appreciation is not taught anymore, which is a shame. Experiencing possibilities, getting a chance to know different things is so important for growing up and developing yourself.

The basic fundamentals of experience are lacking in the schools, getting kids to understand: this is music, this is what theater is, this is painting. Schools don't share that information, and that's the question: why is the information not shared?

I'm dyslexic, so reading took a little while for me, but I could always describe what I saw. There are an awful lot of dyslexics who go into the arts, because for us it's a way to communicate that is safe and comfortable. Whether you're a painter or a dancer or an actor, it's a way to present yourself that you feel is normal.

I would much rather see children with the arts making things happen, whether it's a story or whatever, than see them just idle and not having at least a chance to be creative. I think it's very foolish of us not to offer an alternative to what's out there. And what's out there isn't very much for the kids now. There are very few music programs in schools. There are no arts programs. They talk about there not being enough money to take care of it. But somehow they managed to find a way in my generation.

I think that if you're not given the opportunity to experience the arts, you're missing out. And I can't imagine that anyone's intention is to deprive a child of his or her creativity. I can't picture a world like that, and yet it seems that that's the world we're living in.

I think that the idea that somehow the arts aren't as important as reading, writing, and arithmetic is generally held by people who haven't had a child who needed other ways to learn. Once you have a kid like that, I believe that it becomes crucial to you to find a way for your child to participate, and the arts have always seemed to be one way that people were able to learn whatever they needed to learn, whether it was numbers or reading or whatever. I mean, the arts have a place for all kids, really; no one is left out of the arts.

I don't think that people are closing down access to the arts purposely. I think it's something that they are doing because they've forgotten what it was like for them, because it was so normal to have it as part of your growing up.

Kids who have the least access to the arts might be those that have the greatest need to have them. You couldn't go to school when I was a kid without learning band. Whether you liked it or not, you had

band. You know, you were given the arts; it wasn't something that someone had to think about. It was something that just was. You got the arts. That was part of schooling. And I just find it almost incomprehensible that people don't have the same relationship to it as I did when I was a kid.

I grew up in New York, so my best experience is when Joe Papp brought the arts to the neighborhoods. He was funded to do it in the summertime, so they came to the neighborhoods. I find it incredible that people don't remember the traveling theater that Joe Papp put together for us. Why isn't that part of parks and recreation today? It just doesn't make any sense. I looked forward to seeing those actors come through, and I know that everyone in the neighborhood, whether they wanted a life in the arts or not, brought the kids out to see these wonderful actors doing Shakespearean plays; it just was part of your upbringing.

As soon as you cut the arts out, you remove a very important lifeline. When I was growing up, you could go to Broadway because they could afford to take huge groups to see plays. Your school took you, your church group took you—this was part of your life. This is not economically feasible now when tickets cost a hundred bucks. You can't take people to the theater the way you used to. You used to be able to get really great student discounts, which is how I saw my first play—James Earl Jones and Jane Alexander doing *The Great White Hope*. When that man stood up there, he was bigger than the building. I mean, I knew there were actors because they always made a speech every time the Academy Awards came on, so I knew there were actors, but there is nothing like the smell in a theater and a

brilliant performance, because it mesmerizes, it electrifies, and you want to get up and say, "F— yeah! Yeah, this is what it is!"

That's the experience that the arts can give you. It's the same as when you go and you look at a painting and you say, "Oh, my God, I don't know what this means, but I love this. I taste it when I look at it." It's something that happens to people when you give it to them, when you offer them, when you say, "Look at this or look at this." Or when you hear a piece of music. If you take that away from children, if you take that thing that resonates in their minds away, where they know in their gut when something touches them, you eliminate so much for them; you limit their possibilities, you limit their worlds, and I still don't understand why this is not a huge argument in our country.

As a kid who was dyslexic and did not understand things the way that other kids might have, the arts were very important to me. They were very important to the way that I saw the world. I'd also say that they are for everybody. And I would like President Obama to find a way to make that as important as anything else that's happening in the school system. I don't believe that children are learning what they need to learn unless they are also being given an artistic eye. Whether it is someone teaching them how to make pottery or paint or dance—whatever it is. It shouldn't be a rarity but rather what is done under normal circumstances.

I would urge us all to put money into the arts. I realize that there is a lot of stuff to do, but I believe if you are really concerned about young people, then you want to give them every opportunity to see what kinds of things they're actually made of. And I believe that one

of the only ways you can do that is if you give them an artistic voice and let them create things.

I think what the arts can do is give kids the opportunity to find different ways of having a voice. I think you have a different voice when you have the arts. It's another opportunity for you to be part of the fabric of the country. And you know, you might find the next Maria Tucci, or the next Whoopi Goldberg, poor thing.

Diane Ravitch

Diane Ravitch is research professor of education at New York University and a historian of education. In addition, she is a nonresident senior fellow at the Brookings Institution in Washington, D.C. From 1991 to 1993, she was assistant secretary of education and counselor to Secretary of Education Lamar Alexander in the administration of President George H.W. Bush. As assistant secretary, she led the federal effort to promote the creation of voluntary state and national academic standards.

Among her books are: The Death and Life of the Great American School System: How Testing and Choice Are Undermining Education; The Language Police: How Pressure Groups Restrict What Students Learn; The Troubled Crusade: American Education, 1945–1980; *and* The Great School Wars: New York City, 1805–1973.

Whoopi Goldberg had an unusual New York City childhood. She attended a Catholic elementary school, skipped high school, and seems to have gotten most of her exposure to the arts informally, by

visiting museums and observing what was happening in the streets. She was born in 1955, so she came of age during a time of social upheaval, when the streets were filled with plenty of action.

Whoopi didn't rely on the public schools or even her Catholic school to introduce her to the arts. She seems to have done very well on her own, taking advantage of all a vibrant city had to offer. Nonetheless, she feels strongly about the responsibility that schools have to make sure that students have the opportunity to become engaged in music, dance, and the various forms of the arts.

Quite by coincidence, I received a report about the state of arts education in New York City on the same day that I opened the e-mail containing Whoopi Goldberg's thoughts on this topic. The Center for Arts Education, which is the leading advocacy group for the arts in the schools, issued a dire warning that funding for the arts was falling, even before the current economic recession began. Whoopi needs to talk to Mayor Bloomberg.

In 2007, the Bloomberg administration decided that every principal should control his or her own budget, so the mayor's office eliminated a program of dedicated funding called Project Arts. The money allocated by this program, when it existed, could be spent only on the arts, and as the Center says, Project Arts proved to be "a financial engine which provided incentives for the hiring of additional arts teachers, the purchase of arts supplies and equipment, and the formation of partnerships with arts and cultural institutions to enrich in-school arts education."

In place of this dedicated funding for the arts, the Bloomberg administration instituted something called "ArtsCount," which meant

that arts programming would factor into each school's accountability rating.

The result, three years later, is that there has been a precipitous 31 percent decline in spending for arts education services in New York—that is, the services of arts and cultural organizations to bring arts education directly to schools—and a dramatic 68 percent decline in spending for supplies and equipment.

The Center for Arts Education observed that these declines in spending were "symptomatic of the current school accountability system, which has placed an ever-increasing focus on state exams in just two subject areas—Math and English Language Arts." By 2008–09, the city spent only about $3 per student for art supplies and equipment, for a total of $3.4 million, a shockingly small allocation in a budget that is more than $21 billion. The report warned that "The disinvestment in the key elements of arts education that we are witnessing, and the general shift away from a well-rounded comprehensive education for our children, is likely to be exacerbated by the imminent budget cuts slated for public schools."

I wonder what happens to children like Whoopi in the current climate in public education in New York City—or in most other districts in the United States. Public schools have been trapped in accountability hell for the past eight years as a result of the federal No Child Left Behind law. The law mandates that test scores must go up every year, and that by the year 2014, every student must be proficient. If schools are unable to keep pace with this demand for years in a row, they may be closed or privatized and their staff may be

fired. Testing has become the centerpiece of American public educa-
tion. Children spend weeks, sometimes months, preparing for the
all-important state tests. The scores will determine the fate of the
students, their teachers, their principal, and the school itself.

The pressure to raise scores has driven out time for subjects that
are not tested, and usually the first subject to be pushed aside is arts
education. Music, dance, painting . . . they don't count, so they can
safely be ignored. Other subjects fall away or lose times as well, such
as science, foreign languages, history, civics, and geography.

In Whoopi's hometown, the mayor decided to stake his legacy
on raising test scores in reading and math. So the city invested hun-
dreds of millions of dollars on test preparation materials and on its
prized accountability initiative. Educators waited each year for the
scores, hoping to win a bonus and fearing that their school might be
closed if the scores did not go up.

Year after year, the scores did go up, and the scores enabled the
mayor to win a second term and then a third term (after persuading
the City Council to overturn a term limits law that had been twice
endorsed in referenda). The mayor and the chancellor of schools
traveled the nation, testified in congressional hearings, and even
went international to boast of the test score gains in New York City.
Other cities debated whether to switch to the New York City model
of mayoral control—with no checks or balances on the mayor's
power—because of the impressive test scores.

Then, in 2010, everything changed. The State Board of Regents
commissioned a report which found that the state tests had become

so predictable that students could pass them by good guessing and that passing the state tests was no mark of proficiency. Under pressure to make the tests more rigorous, the state commissioner of education raised the bar. When the state scores were released in July 2010, the state and the city of New York got a shock. Passing rates plummeted. The "historic gains" that Mayor Bloomberg had boasted about disappeared overnight.

So much effort and so many hundreds of millions of dollars had been expended to raise test scores over eight years, and suddenly the gains were gone. Overnight, the public had to deal with the astonishing realization that the measure that had defined "progress" was fundamentally flawed. In fact, it became apparent that the measure had no intrinsic meaning and that it meant whatever the people in power said it meant. The tabloids, which had been loudest in championing "accountability" and in hailing the scores when they were soaring, wrote editorial after editorial in an effort to stem the crisis in confidence.

It is not clear whether the public will buy the rationalizations and excuses. They might. Or they might not.

In my dreams, I imagine incensed parents, enraged university professors, and chagrined employers demanding a far, far better education. I dream that they insist that education be seen as something different from the degraded, test-obsessed culture of the past eight years. I imagine them insisting that all students have the opportunity to learn to play a musical instrument, to sing in a group, to create videos, to sculpt, to dance, to let their imaginations run free under the guidance of a qualified teacher of the arts. I imagine

schools where students learn to speak a foreign language, discuss history and politics, and study science.

But for my dream to come true, we need celebrities like Whoopi Goldberg to get involved, to join the Center for Arts Education, to lead the fight for change.

8

"The Only Thing That Will Save Us from Ourselves":

The Arts, Social Engagement, and Social Transformation

Moisés Kaufman

Moisés Kaufman is a Tony- and Emmy-nominated director and play-wright. Mr. Kaufman's plays The Laramie Project *and* Gross Inde-cency: The Three Trials of Oscar Wilde *have been among the most performed plays in America over the last decade. The* Laramie Project *is about the 1998 murder of gay University of Wyoming student Mat-thew Shepard in Laramie, Wyoming. The murder was a hate crime motivated by homophobia. The play draws on hundreds of interviews conducted by Tectonic Theater Project (Mr. Kaufman's theater com-pany) with inhabitants of the town.*

Mr. Kaufman also directed the film adaptation of The Laramie Project *for HBO, which included in the cast Peter Fonda, Laura Lin-ney, Christina Ricci, and Steve Buscemi among others. The film got four Emmy nominations. On Broadway, Mr. Kaufman directed the Pulitzer Prize and Tony Award–winning* I Am My Own Wife; *his own play* 33 Variations *(Tony Nomination) with Jane Fonda; and*

Bengal Tiger at the Baghdad Zoo *with Robin Williams, which was a Pulitzer Prize finalist. Mr. Kaufman is a Guggenheim Fellow.*

My childhood was marked by a great lack of arts education. There was no theater group in my high school. There was a choir but I don't have a good voice so. . . . In fact, growing up, I knew that artists existed, but I had never met an artist in person. Artists were people in books and novels. Not in real life. So I never thought I could be an artist.

It wasn't until I was seventeen years old, when I went to college in my native Venezuela, that I had any arts training. I was studying business administration and I hated business administration—I couldn't see my life in that field. So I went to the extracurricular activities center at the university and said, "What artistic activities do you have?" And they said, "Well, we have the theater group," and I was fortunate enough that the theater director of that company was a great artist. I was with that company for five years. That's how I became a theater person: first as an actor and then as a director. That saved me. I was also fortunate in that my dad was a very avid reader and he was always talking about the books he had read: Spinoza and Schopenhauer and Somerset Maugham (very light reading, as you can see). His passion inspired in me a hunger for stories. But there was no formal education that I received early on in the arts. And that was perhaps the greatest tragedy of my education.

A friend of mine runs a street conservatory in Albuquerque, New Mexico. She says she doesn't believe that art changes life. She believes that only *great* art changes life! Isn't that a wonderful idea?

Arts education is not about doing after-school programs so that children can have a place to go or something else to occupy their time. I think that a rigorous arts education is the best way to teach children. Art has a civilizing influence and it's the highest form of discourse. That's why it's so subversive and that's why it's so frightening. A perfect example of how frightening it can be is the controversy around *The Laramie Project* being performed in high schools. Although the play is frequently done in professional theaters and universities around the country, high school boards and principals are often trying to stop productions of the play on their premises. The play should definitely be done in high schools because it talks about how we construct community, how we construct societies, and how we build societies in which we can live.

The arts are enlightening. We live in times of great darkness. Youth is a time to encounter serious ideas and issues. Art is a discourse; it is not only entertainment and it is not only fluff and it is not the thing one does when one doesn't have anything else to do. Art provides an insightful, enlightening discourse and children should be exposed to it. They are able to absorb it, and they need its challenges.

One of the things that moved me the most in recent years was when I saw a production of *The Laramie Project* done in a high school and this thirteen-year-old boy got up onstage; his voice hadn't yet broken, and with a very high-pitched voice he said, "My name is Harry Woods and I'm a fifty-three-year-old. I've lived in Laramie all my life and I'm gay." That was so thrilling to me because here was this thirteen-year-old boy in a rural town in America,

trying to understand the experience of a fifty-three-year-old man who was gay and who was living in another small town in America. This kid had spent weeks and weeks rehearsing this role and trying to understand this man! Imagine the conversations that were happening at his parents' home, the conversations he was having with his friends—"Oh yeah, I'm playing a fifty-three-year-old gay man"—what kinds of conversations did that generate? To me, that is the true power of arts education, that it advocates the expansion of a certain kind of dialogue and debate. And perhaps the most important thing that art can do is advocate for an enlightened dialogue in dark times.

I would venture to say that the main thing that great works of art achieve is that they put us in touch with our humanity, because they make one feel that somebody else understands one's experience. The work of art is where one finds solace. As John Keats said about poetry (but I think it applies to all forms of art): "[Poetry] should strike the reader as a wording of his own highest thoughts, and appear almost a remembrance."

My last play, *33 Variations*, is a play about how characters in the periphery of what we consider "healthy" existence survive. When I directed *I Am My Own Wife*, it was about a German transvestite who survived the Nazis and the Communists wearing high heels. To me those are portraits of survival. A lot of my work is about *the other* in society: whether it's Oscar Wilde, who was the subversive artist who was tried and imprisoned for his art, or whether it's Matthew Shepard, or whether it's Katherine Brand, the lead character in *33 Variations*. I'm very interested in the stories of outsiders—characters

that for one reason or another are put in a society that is foreign to them.

I had a very powerful experience early on. I grew up in an Orthodox Jewish community in Venezuela, which is a very Catholic country. By the time I was nine I realized I was gay. So here I was, a gay boy inside a very Orthodox Jewish community within a very Catholic and macho country. I was living in a world of several ideologies that saw me as abhorrent. And a large part of the problem for me was that I didn't have any role models in Venezuela. Earlier I said I knew no artists. I also didn't know any homosexuals. For a long time I thought I was the only homosexual in the world. And then when I started reading about homosexuality and other homosexuals, I had a similar reaction to reading about artists. They existed out there, but I wasn't one of them. Or couldn't be.

But then, when I was seventeen, a cousin of mine decided we were going to take a cross-country trip in the United States. And we ended the tour in San Francisco, and they were doing a production of the beautiful *Torch Song Trilogy* by Harvey Fierstein, and all of a sudden in that play, on that stage, there was a flamboyant drag queen, there was a straight-acting gay man, there was fifteen-year-old gay boy, and I was sitting there. They tell you in school the purpose of theater is to achieve catharsis. When was the last time you went to the theater and achieved catharsis? But when I went to see *Torch Song Trilogy* I had a cathartic experience because all of a sudden I thought, *Look! I can be any of those people up there.*

I believe that the artistic community is called upon to lead the most enlightened dialogue. Oscar Wilde said, and I'm paraphrasing,

when they asked him about politics and art, that art is a higher domain than politics because it addresses so many parts of the individual—the intellect, the emotion, and the spirit, which is why the arts create a very powerful discourse. We have this premise that we live in a democratic society, and in a democratic society all people are equal. And yet daily we are confronted by the fact that we are not. We live in a very stratified society, and we still have a great deal of poverty, and we don't all have the same opportunities, and civil rights violations happen continuously. So at this particular moment in time we are failing miserably.

But I think that art is a particularly good medium to articulate our failure. And to do so in a way that reconnects us with our humanity. *The Laramie Project* is an example of how art can reveal the contradictions and complexity of experience. We went to Laramie after Matthew Shepard was murdered and we saw a community that was at war with itself. In the words of the people of Laramie, we learned all the "ideological fault lines" that are dividing our culture. Did Matthew Shepard get killed because he was gay? Absolutely. Was he also killed because there was a town/gown divide in Laramie and the two kids that murdered him were part of a town that views the university with hostility? Was it about class? Absolutely. Was it about the fact that Matthew Shepherd was effeminate (so that the two murderers reacted to the fact he didn't fit their definition of masculinity)? Absolutely.

So the play is able to talk about these "fault lines" that divide our culture. The play is able to talk about class, sexuality, gender, and sexual orientation. It talks about violence and education. And by

portraying the dialogue that is happening in that town, and the different points of view of the people of that town, the play gives a way in for an audience member to see their own point of view reflected in the play. The theater is a place where we can lower our defenses and look at ourselves from a different perspective.

What we do in theater is create worlds that don't exist. And that, to me, seems like an exercise in visualizing the world in which we wish to live. Perhaps more important for any artist, or rather for me as an artist—I'm going to speak very personally—are the two things that have always guided me in art: desire and imagination. Imagination is the only thing that will save us from ourselves. Imagination departs from the premise that what is occurring in the present, what is existing right now, is not sufficient, so that imagination must transform it. And I think that's what we do in the theater; we imagine. Imagination is always a subversive thing, because imagination is about discontent with the status quo.

Tectonic, my theater group, has an educational branch. We teach workshops both in New York and across the country. In universities and theater schools. We have developed our own methodology and our own way of working called MOMENT WORK. And that's what we teach. It's a technique to create and analyze theater. It's a technique to write performance as opposed to writing plays.

Tectonic was born out of discontent with the status quo, and what I was worried about when I created the company was that so much of the work one sees in theater is either realism or naturalism, which are really nineteenth-century forms. Tectonic means the art or

science of structure. It implies an exploration of forms. And we are interested in what are the new theatrical vocabularies, the new theatrical forms. How can we keep theater alive? Why is it that most theater one sees looks like film and television? And how do we allow theater to find its own vocabulary and speak in its own terms? One of the great things about studying with Stella Adler was being in classes where she would pose the question "*What about this style?*" She never assumed that naturalism or realism were givens. She had a very keen intellect and a very keen insight into how different writers dealt with form. I think that, looking at Arthur Miller's *Death of a Salesman*, we always think of that as a realist play. Well, the form of that play is anything but realistic. Or *The Glass Menagerie*, which is a memory play where the lead character directly addresses the audience. So to me, the purpose of Tectonic is to continue exploring what are the theatrical forms that can keep theater alive. *Gross Indecency* was created specifically from literary sources. When I started writing it I immediately became aware that there were many different versions of the story from the people who were there at the time, so in my naivety I wanted to write *the story* of the trial of Oscar Wilde. Well, of course that was impossible because there were so many different versions of the story! So the play that I created was a play that didn't say *This is what happened to Oscar Wilde*, but rather *This is a version, a* Rashomon-*like play* where you saw all the different participants stating their versions of events, but the audience gets to make their own decision about what happened. It was a play about the impossibility of reconstructing history. I would not have been able to have this conversation in a kitchen-sink realistic play.

In *The Laramie Project* the form was very different, in that I thought, *Could we, as a theater company, go to a town, talk to the people of the town, come back and make a play out of that?* One community getting to know another community—that was the form of that play. *I Am My Own Wife* is a one-person play that really explored issues of gender and identity. And *33 Variations* is a play in variation form, about how we can revisit the past in music.

Each time we do a play we really deal with two questions: not only the story of the play but how is the play furthering our study into the theatrical vocabularies. And so what we teach our students is the technique of how we can devise and create theater using these ideas.

Augusto Boal, the renowned Brazilian theater director, writer, and politician, was a teacher of mine. The theater of the oppressed is a fantastic, a very specific form that Augosto came up with, right? And it was very empowering. He used Paulo Freire's phrase "pedagogy of the oppressed" to create Theater of the Oppressed. What he was most interested in was in dialogue between stage and the community in which it was created. That is not my focus, which is to continue to create theater that reveres its own poetry, its own language.

How do we write theater that is not about exclusively the text? Right now we're still doing the thing where a writer goes into a room, spends twenty years in a room writing a play, then she comes out of that room, hands it to a director, and the director spends three weeks in a rehearsal room and one week of tech and then they have a play. To me, that only leads to theater that is like a very poor illustration of a text. What I'm excited about is how we construct narratives that

are uniquely theatrical. Can we teach our playwrights to write *theater*? Can we teach our playwrights the power of a cross, the power of an object; you know, to write theatrically?

What Augusto Boal did for me was to show me how rigorous you had to be when creating an aesthetic and how rigorous you had to be when exploring theatrical forms. And so he was very influential. Mary Overlie and the Six Viewpoints were very influential as well. Stella Adler was influential in her rigor and her way of considering different ideas. At Stella Adler you learn to love that which is not pedestrian.

Steve Seidel

Steve Seidel has worked in arts and education for over thirty-five years. He trained and worked professionally as an actor and, later, as a stage director in theater companies in Baltimore, New York, and Boston. Steve has also worked on short and feature-length films as an acting coach, writer, and script consultant.

Steve began working in schools in 1971 as an acting and language arts teacher, and coordinated the arts program at The Group School in Cambridge, Massachusetts, an alternative high school for low-income and working-class youth. He also taught for eight years at South Boston High School as lead teacher and coordinator of the Theater Company of Boston's federally funded collaboration with the Boston Public Schools.

Steve currently holds the Bauman and Bryant Chair in Arts in Education at the Harvard Graduate School of Education. From 2000 to 2008 he was the director of Project Zero, a Harvard research group that aims to understand and enhance learning, thinking, and creativity in the arts as well as humanistic and scientific disciplines at the

individual and institutional levels. He has been the director of the Arts in Education program at Harvard since 2004.

Over the seventeen years I taught theater in high schools, I worked with many students who told me that drama class was really different from most of their other classes. Of course, there were the obvious differences—we were up on our feet, not sitting at desks; we created original work, rather than simply studying the work of others; we shared the product of our study in live performances for appreciative audiences, rather than concluding the term with an exam. But students also noted the very different social dimensions of those classes. Sometimes they said we were like "a family." They noted that everyone contributed to the work and that the class was a place they felt they could honestly say what was on their minds.

Sometimes they noted what I had often observed—many who participated comfortably in drama class were students who seemed to feel uncomfortable, shy, angry, or unfocused in most other classes. Some of these students had what were labeled learning disabilities, others were gay or lesbian, many were artists (though they often didn't have that word to articulate that identity), and all, in the schools in which I taught, were working class or poor. Indeed, some were all of the above. Both in and out of school, many of these young people engaged in desperate and self-destructive behaviors, yet when in drama class and settled into the work, they brought tremendous energy, intelligence, insight, compassion, and humor to the group.

Not surprisingly, I was intrigued when I discovered Jeff Perrotti and Kim Westheimer's book *When the Drama Club Is Not Enough: Lessons from the Safe Schools Program for Gay and Lesbian Students* (2001). In the book, the authors explore the misery and danger that results from the almost uniformly unchecked homophobia that dominates most schools in the United States. The situations they describe are horrifying but well backed up by equally disturbing statistics. Consider this testimony from an eighteen-year-old at hearings on the experiences of gay, lesbian, and bisexual youth in Massachusetts:

> I felt as though I was the only gay person my age in the world. I felt as though I had nowhere to go to talk to anybody. Throughout eighth grade I went to bed every night praying that I would not wake up in the morning, and every morning waking up and being disappointed.

This experience is neither isolated nor unusual. In 1989, the U.S. Department of Health and Human Services produced a report on youth suicide revealing that 30 percent of these suicides in the United States were committed by gay, lesbian, and bisexual young people. The 1999 Massachusetts Youth Risk Behavior Survey, on which young people are invited to identify their sexual orientation, revealed that, in relation to heterosexual young people, lesbian, gay, and bisexual youth are approximately four times as likely to attempt suicide, three times as likely to have stayed out of school due

to feeling unsafe, three times as likely to have been threatened or injured with a weapon at school, and five times as likely to have been in a physical fight resulting in medical treatment by a doctor/nurse.

Perrotti and Westheimer also discuss the issue of homophobia in the context of the dire consequences for so many more students of unchecked racism and sexism in schools and society.

What Perrotti and Westheimer don't explicitly explain in their helpful and hopeful book is their choice of the title, *When the Drama Club Is Not Enough*. Implicit in that title is the idea that high school drama clubs have perhaps been the only "safe" place for LGBTQ youth in many schools. Their argument, and an absolutely appropriate one, is that every classroom, hallway, cafeteria, administrator's office, playing field, and elective activity should be a safe space for all young people.

Through my experience as a theater teacher and for many more years as a researcher studying the arts in education, I've come to believe that drama and the other arts do have the potential, with skilled guidance, to be safe spaces in schools for any and all students. But there is no guarantee that this goal will be achieved simply because drama is the subject matter. Nonetheless, given this potential, it is critical to ask what lessons might drama—and the other arts, as well—hold for those who, rightfully, want to see the whole school as a safe space?

Moisés Kaufman provides a number of useful insights into the perception that "the drama club" is (or can be) a safe space for LGBTQ youth in otherwise often unsafe schools. He points us to four aspects of the arts that have relevance for this inquiry:

- The arts as transformational learning
- The arts as discourse
- The arts and social imagination
- The arts and quality learning experiences

While Kaufman often speaks of the arts, he is usually most specifically talking about theater, his own primary artistic form.

Drama programs in schools seem to become the territory of a particular group of students, often given names like "the drama kids," "the artsy types," or "the freaks." These settings, while safe for some, may not feel welcoming, inclusive, or safe for many other students. The class, race, and sexual orientation issues surrounding these groupings are enormously complex and create a difficult situation for the students, teachers, and the school. In these situations, the theater program may feel simultaneously safe and dangerous for those students in the program—they accept each other (creating a safe space in that room), but become stigmatized within the larger school community (creating feelings of isolation and danger around the school). And other students, who may well have an interest in theater, may not feel welcomed into the drama club by the students in the program and/or not want to be associated with those students by other students in the school. In short, the image of the drama club as a safe space may be both far too simplistic and yet, in substantive ways, true.

The challenge of creating a welcoming and inclusive space for all students raises particular issues for a theater program, including, among others, what plays will be chosen for performance, who feels

welcome to participate in the program, and the image of the arts and drama in particular in the school and its larger community. In any case, one cannot assume that the drama club is a safe space for *all* students; one has to make it so.

One of the lessons of the Massachusetts Safe Schools Program is that creating safe spaces seems to demand articulation and practice of the values of respect for and the embrace of diversity, including the explicit statement that racist, homophobic, sexist, able-ist, and other intolerant and prejudiced comments, assumptions, and beliefs will be challenged when expressed—even as we acknowledge that any and all of us (students and teachers) are quite likely to bring these attitudes into the room.

Perhaps the goal of an educational setting could be to make us aware of these ideas and assumptions so we can examine and question them, try to understand their effects on others, and reconsider our own relationship to them. To talk of the drama club as a safe space does not mean that there is never a threat or any discomfort in the room. It means that there is a commitment to examine whatever comes up that makes the space feel unsafe to anyone.

If we accept that the world with both its beauty and ugliness pours into the classroom each day when teachers and students walk through the door, what insights might Moisés Kaufman's profound experiences and insightful reflections provide in grappling with the ugliness and nurturing the beauty?

THE ARTS AS TRANSFORMATIONAL LEARNING

Kaufman reflects on the various and powerful ways in which he experienced isolation and hatred growing up:

Double despised, as gay and Jewish, Kaufman was also searching for a way to become something for which he had no models. In all three realms—religion, sexuality, and vocation—Kaufman felt excluded and isolated. Though his father was an avid reader and books were highly valued in his home, he had no formal opportunities to study any of the arts in school—"and that was perhaps the greatest tragedy of my education." It wasn't until college in Venezuela, where Kaufman was enrolled in a business administration program, that he went to the extracurricular activities center and discovered . . . the "drama club"!

Indeed, two experiences with theater were transformational for Kaufman—first, an encounter with a work of art and, second, an encounter with a powerful theater community. By Kaufman's account, the first transformation took place in one evening at the theater, the second over a period of five years. Transformations can be both fast and slow.

The thrill and significance of identifying with the characters in *Torch Song Trilogy* provided Kaufman with many things in that moment, not least of which was the discovery that he was, perhaps, not as odd, isolated, and alone as he had felt. He could, through Fierstein's play, see a path forward for himself that included people he could think of as role models.

Much has been written about adolescence and the difficulties

of developing a sense of one's identity that takes into account both where you come from and where you feel yourself going. If that identity does not conform to established social norms and involves any significant countercultural characteristics or explicit rebelliousness, those years are likely to be turbulent, at the least. Few schools are intentional and systematic in supporting rebels and those who stand outside traditional roles. Indeed, young people who stand outside or against the mainstream norms of the school are often the first to leave school, sacrificing their education to protect the integrity of their emerging identities and their values.

If a school does not recognize lesbian, gay, bisexual, transgender, or queer youth as having a rightful and protected place in that community, it is highly unlikely these young people are going to want to spend their days there.

Exclusion isolates and isolation is deeply destructive to normal and healthy development. Indeed, it is difficult to imagine a healthy learning environment that tolerates any student, teacher, or other member of the community being excluded or isolated. When the reason for that exclusion is linked to a fundamental aspect of one's identity—gender, race, social class, sexual orientation, first language, physical or cognitive abilities, for example—the resulting isolation is especially profound. Given that being part of a community is a basic need in human life, exclusion from a community on the basis of one's identity is cruel. To allow this to happen in schools is to allow the school to be the site in which we demonstrate, teach, and, therefore, condone one of the most dehumanizing lessons about what people can do to each other.

Kaufman suggests at least two ways that drama and the other arts create a safe space to be one's self, whatever that identity might entail. First, he probes the nature of art—what it does for people—and notes that "the work of art is where one finds solace." Dramas can provide comfort in knowing that others share your values, identities, and experiences, however difficult or painful those experiences may be.

Indeed, the capacity of a drama to probe the emotional dimensions of an experience makes it a particularly powerful arena for establishing human connection. Plays help us realize, both through our identification with diverse characters and through our experience of sitting in theater with a group of people who are also laughing and crying, that perhaps we are not quite so alone in this world.

Although Kaufman talks about the characters he saw and identified with onstage that night in San Francisco, he also saw the work of a playwright, actors, designers, and a director—a community—committed to the practice of theater that revealed a world most often kept "in a closet." The discovery of this kind of committed artistic work and life was clearly also stunning to the young Kaufman. In that moment, perhaps, Fierstein and his associates had planted a seed in Kaufman that would grow into the moral imagination that has provided direction for his entire distinguished career in the theater.

Though he does not provide much detail, Kaufman is clear that his five years of active dedicated work with the theater company at his college was life-changing. In that environment, he clearly felt safe

enough, supported, and inspired to make that company a central, if not *the* central, activity of his college career and, in turn, his professional life. Kaufman also reveals that his education in the theater has been an ongoing enterprise, one that has been enriched by working with great artists who are also great teachers and has included shifts over time from starting as a student, becoming an artist (while continuing his study of the theater), and then incorporating teaching into his own work as an ever-evolving theater artist.

Kaufman's naming of these two experiences serves as a reminder that both experiencing works of art as an audience and making works of art are critical aspects of a powerful education in the arts. Indeed, linking seeing and making can be a highly potent combination in many areas of education. If students only read history—even excellent historical works—but never conduct any kind of genuine historical investigation, they remain at a loss as to what the actual work of a historian is. The same can be said of work in the sciences, mathematics, or any other discipline studied in school.

This is important not only to help young people discover those realms of activity that might be especially compelling to them, sometimes leading to the discovery of one's life's work. It is also critical to helping students understand the deeper nature of a discipline as a way in which knowledge is debated and constructed in a field. Disconnecting seeing from making, as is the case so often in schools, reinforces a kind of passivity in students—their perception that the message of schooling is that you are supposed to take in what others have done but not create original work. The experience of being both a creator of valuable work as well as a critical, thoughtful audience

for the work of others shifts the image of the student in his or her own mind to one of an active contributor, highly engaged in the real work of a particular field, even if not quite yet at a professional level. Whether in theater, science, politics, or other realms, student work can be serious, rigorous, and a significant contribution to one's community, but only if seeing and making are both seen as appropriate roles for young people and if both are seen as essential elements of powerful learning in school.

THE ARTS AS DISCOURSE—
CIVIL, THOUGH OFTEN SUBVERSIVE, TOO

The desire to create a safe space for all students in a classroom or school is different from achieving it in practice. It is not possible to keep the world out of the classroom, nor, ultimately, is it desirable. The challenge is what to do when these painful and difficult attitudes make their presence known in the classroom and are destructive to individuals, the community, and the prospects of a healthy learning environment. The problems are multiple—what to say, how to respond, what kind of conversation to start, how to encourage all voices to join in the discussion, and how to ensure respect for all.

Any serious consideration of the role of the arts in education, especially related to the creation of safe and inclusive educational settings, will certainly include a rigorous examination of the various functions of the arts—the ways in which the arts operate and the effects they have on individuals, communities, and societies.

Kaufman has probed both his own experiences in the audience and as an actor and director to consider the nature of artistic experiences. While it might seem the moral responsibility of educators to provide a space for young people to look at and critically consider what is happening in their world, this conversation is largely absent in most schools. It is certainly reasonable, in 2011, to argue that the past decade devoted to "leaving no child behind," a powerful and worthy goal, has turned out to be a decade devoted to limiting what is taught and how it is taught in schools. It may not be a great stretch to suggest that this widely acknowledged narrowing of the curriculum has been an attempt to further constrain what gets talked about in schools, virtually eliminating any possibility of critical, analytic, morally oriented examination of contemporary life.

Of course, when there isn't time for serious dialogue as part of the "core" activities in schools, insofar as this kind of discourse occurs at all in schools, it is pushed to the edges. In this context, the possibility of "enlightened dialogue" in schools becomes ever more a province of the margins—the realm of electives, clubs, and after-school activities—the territory the arts inhabit in most schools. If Kaufman is right that theater is an enterprise that is especially well designed to provoke and support "enlightened dialogue," then there is a natural synchronicity here—theater, and the other arts as well, in a sense, are an especially rich space for an often missing, but critical, function of schooling.

This capacity to serve as a space for an essential educational dialogue provides both opportunity and challenge for those who teach

the arts. The standard stance of arts education advocates is to fight for a place for the arts in the mainstream curriculum, as core subjects in schools. It is certainly hard to argue against this dream. But, insofar as the purpose of engaging young people in serious theatrical work is to create a safe space for serious dialogue about critical issues in contemporary life, the generally conservative stance of public schools toward conserving and accepting the social order will continue to push the arts to the margins. A particular tension, then, confronts educators who embrace the arts as serious discourse—civilized, yet subversive, too—about the world. For better or worse, there is no significant indication that the place of the arts in the curriculum and the life of the school will undergo a radical reconfiguration in the immediate future. Given this, arts educators must probe their deepest understanding of their educational purposes and then how they can best situate themselves to achieve them. The margins may provide a time-honored space for creating both safe and subversive territory in which to work both with integrity and in innovative ways.

THE ARTS AND SOCIAL IMAGINATION

In the moment that Kaufman was watching *Torch Song Trilogy*, Harvey Fierstein, the author and star of the play, and his theatrical compatriots, sparked hope and imagination in his mind that would provide direction for Kaufman's entire distinguished career in the theater.

THE MUSES GO TO SCHOOL

The imagination works in many ways, from relatively simple mental imaging (close your eyes and picture the chair you are sitting on) to artistic vision (how might that chair be represented with paint on canvas or carved in stone) to social and moral imagination (how might the world and contemporary life be differently ordered, organized, and lived—by what values and rules, for example—to achieve greater equity and social justice), to name a few. The contemporary philosopher and educator Maxine Greene has discussed the social/moral imagination and its deep relationship to the arts and aesthetic education, describing it as the capacity to look at and see the world "as if it could be otherwise." (2001)

Kaufman similarly identifies the imagination as the human capacity to think and act beyond the given to the possible. He is well aware of the urgency involved in linking imagination with "discontent."

This is imagining that focuses on the world, a society, or an institution, like a school, or a microcommunity, like a classroom, and considers not only what it is (a fundamentally descriptive activity), but what it could be (a deeply imaginative act). Implied in this kind of imaginative activity is a social and/or moral critique—the idea that there is much to question, consider, and often reject in the ways of this world. Guiding the "social imagination" is a kind of moral compass, the source of one's "discontent" with things as they are.

For Kaufman, creating the best possible theater is linked to creating the best possible society. His ideas of the society he envisions inform what he creates onstage, whether drawing the curtain back on hypocrisy or portraying "pictures of survival," as he aimed to do in

the plays *33 Variations* and *I Am My Own Wife*. This is the struggle of an artist guided by a moral imagination.

Similarly for educators, one's ideas of what constitutes quality are informed by broad purposes and values, including a vision of the kind of world one wants to live in. In this regard, a learning experience that leaves some children feeling smart and accomplished while other children feel stupid, incapable, and discouraged will likely fail the test of whether this is the kind of world one envisions, longs for, and aims to create.

THE ARTS AND QUALITY LEARNING EXPERIENCES

Throughout his reflection Kaufman returns to the issue of quality and the need for artistic excellence, rigor, and integrity in the people, the works of art, and the learning opportunities created for young people. He does not call willy-nilly for more arts in schools. While enthusiastic about the possible roles for the arts in a young person's education, he is also demanding. Children do not need superficial encounters with some vague approximation of an artistic experience. They need the real thing—deep encounters with great works of art and brilliant artists. Art, for Kaufman, is not "entertainment" or "fluff"—a diversion for children at the end of the day or when they've "been good."

Kaufman's embrace of this rigor informs all of his thoughts on what will make the arts worthwhile and powerful in schools. He brings the values he developed through his own theatrical training and practice to his vision of the arts in schools, demanding artistic

practice, and the aim of performances that have the power to engage actors and audience in a serious discourse about ideas and aspects of human experience that are profound.

In the context of the current "standards movement" in education, characterized by thousands of atomized bits of information and lists of skills, to talk of quality in Kaufman's terms has, again, a kind of subversiveness about it. He is simultaneously calling for less and far more. And he is calling for a rejection of mediocrity and mindlessness—theater that asks little of its actors and audiences. To realize Kaufman's vision of quality will require everyone engaged in the enterprise—teachers, students, and the community—in an extended act of imagination, creativity, dialogue, and courage.

THE PARADOX OF THE ARTS AS SAFE SPACES

Certainly, as Kaufman so strongly suggests, the "drama club," as well as the other arts, can offer young people a safe space—to be oneself, to explore one's identity both through taking roles in plays and through finding out what it can mean to be who you are in a community that accepts you.

Yet, the paradox of the creation of safe spaces in most schools is that what makes them safe may well be their subversive qualities, the ways in which their existence serves as a proof of the possibility of other ways of being—inclusion, instead of exclusion; acceptance of differences, not the demand to adhere to narrow images of normalcy; an embrace of diverse perspectives, not the avoidance of controversy; encouragement of critical questioning, not passivity in

the face of morally complex situations; the requirement to engage in dialogue, not sit in silence; and striving for quality, not the acceptance of mediocrity. In all of these ways, Kaufman has suggested, the study of the arts forms an especially rich space of possibility and hope.

Insofar as the spaces for the arts in schools—the studios, rehearsal halls, stages, etc.—are places where an alternative culture is created, they become both safe and subversive. In this regard, they have been and will continue to be a haven for those young people who feel at odds with the dominant culture of traditional schools, schools that uncritically accept the often degrading and hurtful assumptions of the larger society. Many of those young people leave those schools in a move that may actually demonstrate their integrity and political awareness, a declaration that they "won't learn" from certain teachers or in particular classrooms as an expression of their self-respect. But some others find safe havens in these schools in the drama club or other spaces in which adults have created an inclusive, respectful culture.

A goal of all educators should be to create whole schools that are truly safe for all students, without bullying or other forms of intolerance. Is this possible? Or is this utopian dreaming—a worthy vision, but so far from reality in most settings that it is unreasonable to consider it a goal within our reach? In that case, in the interest of those young people currently struggling through schools that are hostile to their very presence, we must work in all possible ways to create every safe space we can in whatever corner of the school we can establish and maintain them. Insofar as the arts are one of the most

common, effective, and, as Kaufman suggests, subversive of those spaces, the role of the arts in schools is not only critical, but may also be assured of marginal status.

Indeed, those who would protect the school as an institution for perpetuation of the status quo are probably justified in their instinctive or conscious efforts to keep the arts out of the school building. It is precisely because of the subversive nature of the arts—and the spaces and communities that form around arts learning and teaching in many schools—that they are, justifiably, threatening. The kind of theater and theater education that Kaufman practices promotes and demands engagement in democratic processes of civil discourse and the protection of human rights in the school and community on a daily basis.

Conjuring and holding on to this image of the teacher and the school is a supreme act of imagination and hope. As Moisés Kaufman suggests, in the effort to make this image a reality, "a rigorous arts education is the best way to teach children."

9

"Enriching Society":

The Communal Power of the Arts

Mike Medavoy

Mike Medavoy is an American film producer and executive. His career in film began in 1964, and he worked in various management agencies for several years. In 1974 he became the head of production for United Artists and went on to co-found Orion Pictures in 1978. He served as the chairman of TriStar Pictures in the early 1990s and is currently chairman and CEO of Phoenix Pictures, which he co-founded in 1995. Throughout his career he has played an integral role in the development, production, and release of countless Oscar-winning and celebrated films, among them One Flew Over the Cuckoo's Nest, Rocky, Annie Hall, Amadeus, The Terminator, Dances with Wolves, Silence of the Lambs, Philadelphia, Legends of the Fall, Hook, The People vs. Larry Flint, The Thin Red Line, Holes, Basic, All the King's Men, Miss Potter, Zodiac, Shutter Island, *and* Black Swan.

I was born in China to Russian parents and our family traveled a lot. My parents weren't interested in art. What they were interested in was staying alive, because they lived in China during World War II

when the Japanese took it over. Every time he went to a different country my dad started off as a garage mechanic because he didn't speak the language. Eventually he wound up either running the telephone company or doing some other extraordinary thing. My real appreciation of the arts came with studying history and studying what artists were trying to express through their work.

I was lucky because I had a varied educational experience. All of us start with the arts in preschool, whether it's finger painting or anything else—it's like going to Spain and looking at those cave paintings that were done thousands of years ago. The progressions from there are based on your interest. And your interest is based on having a teacher who can show you how beautiful all of that experience is.

I believe that we should all get the broadest education possible. A cumulative education provides building blocks that seem to come together by the time you leave college. Learning thereafter becomes more specialized, but a broad education encompasses trying to understand how all the pieces of life fit together and attempts to answer the usual questions in life: Why are we here? Where are we going? I wanted my children to have the broadest possible education, so I surrounded them with as much history, music, and art as I possibly could. I have found that everyone is a teacher as well as a student; over the history of mankind, people have made advancements in society by passing along what they have learned.

Art is an arena where we learn to understand emotions and the human experience. Artistic representation forces us to deal with our own feelings. The arts in general deal with self-expression. Art

allows us to walk in another person's shoes. It opens us up, allows emotions to become images of relationships, both good and bad. Some emotions we learn to aspire to, others we learn to oppose because they are unjust. Through art we recognize our commonalities that bridge across great differences in background and experience.

In school, art integrates all of these values and possibilities in the early evolution of a child's mind. It allows talent to grow and—this is very important—encourages children in our schools, from different linguistic and cultural backgrounds, to imagine life together. That is what has helped make us a successful country of immigrants, discoverers, and creative innovators, and that is also why it is so crucial to bring this kind of experience to *all* children. Art is about imagination and self-expression manifesting in forms that enrich society.

Art is an opening to empathy and compassion, both key ingredients for a moral perspective and an ethical politics. For example, we learn from *The Grapes of Wrath* that you can't worry so much about budget-balancing that twenty million children pay the price by going to bed hungry. In the end, that means they fail in school and possibly in life, and the cost of policing and prison is so much higher than the expense of a holistic education.

My career has focused on the art of film. Generally, the core of a movie is its ability to tickle the brain as well as the heart, which represents the emotional part of it. I know I have been successful making a movie if people walk out of a theater and both their brain and their emotional core have been affected. Being a filmmaker requires me to examine all of the arts because film is a synthesis of music, painting, acting, directing, photography, and architecture.

Film deals with daily life and human behavior. Filmmakers explore human behavior by dramatizing images and stories on the screen. Movies entertain and hopefully enlighten, but they also evoke passion and emotion, as do other forms of art. In part, that is why artists have always played an integral role in powerful social movements for justice. They attract media, which is important. But more important, they embody the images they have helped communicate to the larger world. Artists have the ability to show us what we can do when we face challenges, how we relate when we love, and how we behave when we hate blindly.

My own deep commitment to issues of justice is rooted in the fact that I can't envision a world where people are not in search of social justice. It is shameful that twenty million kids are living in poverty, sleeping in motel rooms or in cars. It is impossible for a child to learn in school if he or she is hungry. In a country of considerable wealth it is unconscionable to argue over balancing the budget and then cut education programs for millions of children who have no breakfast, lunch, or dinner. I can't imagine remaining silent under these circumstances.

Education is paramount for survival in today's complex world. In America, democracy and education go hand in hand. This is the most important promise of America. An educated population is necessary for a democracy to flourish, and the arts are an essential component of any education.

Colin Greer

Since 1985 Dr. Colin Greer has been the president of The New World Foundation, an organization that supports progressive activists in their efforts to build stronger alliances for social justice, civil rights, economic, and electoral issues. Previously a professor at Brooklyn College, CUNY, Colin Greer has participated in and directed several studies of U.S. immigration and urban schooling policy and history at Columbia University and CUNY. He chaired the Presidential Fellows Program from 1992 to 1994, and currently chairs or serves on the boards of numerous education, arts, and cultural organizations. A poet and playwright, Dr. Greer has also authored several works of nonfiction including The Great School Legend, Choosing Equality, *and* A Call to Character *(with Herbert Kohl). In addition to formerly serving as the editor of* Social Policy, *he has prepared papers on education for Senator Paul Wellstone, as well as papers on philanthropy for the former First Lady Hillary Clinton.*

The arts derive from the ancient terrain of ritual. In the long millennia of human society, ritual at first served to bind people in community, belief, and expectation of behavior and events.

Rooted in imagination, ritual (religious for the most part) was compelling, inspiring, and contained a strong dose of indoctrination. So people made sense of the world, trying to make it feel safer than it could be with a promise of improvement and/or the great hereafter.

Over several millennia the primitive drive to imagine was superseded. As Spinoza put it, "the drive to imagine" was replaced by "the drive to use the imagination." In this way, the imagination partnered with reason to co-create both our intelligence and our knowledge.

The arts are core to this shift, at once secularizing the imagination and allowing its baser aspects to be observed and acted upon. The arts have evolved to become a major resource for our direct access to and expression of our disciplined imaginative capacities. Artistic exploration and presentation are part of our epistemological adventure as humans venture into the unknown, the poorly known, and the miserably misunderstood. Hence, they are an essential part of the inquiry into understanding the world, making sense of it, and sharing that intelligence with our fellows.

An equally important component of the arts mode of inquiry and communication is indeed the necessity of sharing. Like the proverbial tree in the woods, art is not complete until it is enjoyed by an audience. Many artistic endeavors are collaborative pursuits whereby we test our anxieties (fears for the future) and we create the future, too.

The collaborative character of knowledge building is noteworthy. It is ubiquitous. No information is complete unless received, digested, and acted upon. In the arts the collaborative partnership is wide and builds through the application of affect and reason: deepening our sense of possibility; artist and audience imagine a different world.

It's not always a different and better world, of course. Both affect and reason can lead us along ugly pathways. Just think about Leni Riefenstahl and Gestapo propaganda and heart-wrenching cartoons of blacks lynched by fear and hatred garbed in white sheets. We can, as Michael Medavoy says, walk in another's shoes just as we can condemn them for their shortcomings.

The imagination is the seedling of moral logic and its demonic inversions. Change blows willy-nilly; it rises like wind out of history and tradition and faces the unexpected with a sense of optimism or desperation. But the journey to either is imagined before it is lived and is realized only as enough of us share in the dreams (or nightmares).

Hence the collaborative aspect of our shared imagining is a powerful resource. In the performing arts, the imaginary is serially co-created—among performers; among theater professionals with trades, dramaturgical, and choreographic skills; and with an audience.

Dream or nightmare! The stakes are high. Hence the work of building an audience is essential. When we educate children for life in society, especially a humane democratic one, we must of necessity teach the arts: adding artists and audience.

In my work at the New World Foundation, I have learned the importance of building a strong base in popular support for progressive social policies. At the center is building the engagement and participation of those who suffer most to change the causal nexus of their enduring plight. Leaders and policy makers create new scenarios; political actors and witnesses make progress possible.

Art in the poorest schools is, as I see it, a link in the chain of forming and energizing the heightened sensibility to the possibility of re-imagining the social world—first enchanted by it, next compelled by it.

For Mike Medavoy, the world of the artist is the route to moral logic and action. Twenty million starving children is a crisis of humanity; but to achieve a world of healthy, well-fed youngsters we have to imagine an end to the deep inequalities that prevent that result. It takes imagination to justify starving children while wealth grows so that 400 Americans have wealth exceeding that of 150 million others. And it takes imagination, collaboratively formed, for us to reinvent our social mores. But most important in this journey is that the hungry youngsters themselves imagine that they can expect to be significant actors on the world stage.

Arts education in all our schools is an investment in that democratic capacity. Here we'll find and develop the social conscience robust enough to build rituals of resemblance and transformation.

The arts, yes! And as Carl Sandberg wrote, "The people, yes."

10

"Rebellions, Breakthroughs, and Secret Gardens":

The Arts and Imagination

Maxine Greene

If master educator Maxine Greene, born in 1917, has taught the world one thing, it is that imagination is so much more than mere child's play. Her writing and philosophy place imagination at the center of all human life and thought. Through inquiries into sociology, history, and especially philosophy and literature, Ms. Greene explores living in awareness and "wide-awakeness" in order to advance social justice. She founded the Maxine Greene Foundation for Social Imagination, the Arts, and Education in 2003 and, through it, has supported numerous nonprofit arts groups. She is professor emerita of Teachers College, Columbia. Her Sunday Salons, conducted in her home for decades, are informal and lively discussions of works of literature of contemporary interest. According to Ms. Greene, the full range of human experience is not available to most individuals, but it can be explored through literature and the arts.

Among her books are: The Public School and the Private Vision: A Search for America in Education and Literature; The Dialectic of Freedom; Landscapes of Learning; Teacher as Stranger: Educational

Philosophy for the Modern Age; Variations on a Blue Guitar; *and* Releasing the Imagination: Essays on Education, the Arts, and Social Change.

An encounter with the arts changed my life. I was lucky enough to live in Brooklyn opposite the Brooklyn Museum, and when I was about ten I found out, to my amazement, that on Sunday they had free concerts in the sculpture court. So I started to go over there and I said, "Oh, my God, it's like another world!" It was a world I wanted to be in. I liked it better than my family world. I grew up in a family that discouraged intellectual adventure and risk. To me, the opera and the Sunday concerts in the Brooklyn Museum Sculpture Court, and the outdoor concerts in the summer, were rebellions, breakthroughs, secret gardens. Also, since the age of seven, of course, I was writing.

I went to an Episcopalian school, and they could expel you if you wore bobby sox. What I got there was a formal introduction to literature. We diagrammed sentences and things like that. I think I learned something about Shakespeare. I don't remember anything much about painting or dance. It wasn't emphasized. You know the canon: a nice Christian girl had to know the canon. They had music appreciation and I remember I hated it because they didn't ask you what you heard or how you felt. But I thought if I wanted to be nice, like the elite girls in my class who had horseback riding lessons, I'd better learn music so I could be like the rich kids.

But we weren't allowed to join the local stable, because we were

Jewish, and stables were as anti-Semitic as private schools. My brother used to be a groom there, but we couldn't ride there.

When I was a freshman at NYU, one of the teachers had the very bright idea of going to the museum and just looking at all that we could, and I remember awakening when I realized how Rembrandt used light. I realized that if you looked carefully you could see how the light created the wonderful image. I think that was one of the beginnings; it opened my eyes and took me into a new way of understanding.

I also always wanted to write, so I was a library haunter, and I wrote two unsuccessful novels and spent most of the rest of my time asking, "How did they do that? How did Tolstoy do it and how did Flaubert do it?" I haven't found out, but I still have the questions. I'm still looking. I can't write *Death in Venice,* but I'd like to know how Thomas Mann did that. Those questions still stay with me.

As for education, the thing I'm obsessing about is the boredom in so many classrooms, and boredom, as Heidegger saw it, is very often a response to a sense of meaninglessness. I feel that because of the neglect of imagination, the neglect of thinking in terms of possibility, children think that what happens in school is totally irrelevant to them and to their future. There's nothing worse for education than a feeling of futility. One of my strongest arguments for the arts is the fact that imagination can be stimulated and children can look beyond what is to what might be, to what should be, to alternative possibilities. It's probably the argument I use most in my classes at Lincoln Center. And then people laugh at me because I use the term

"wide-awakeness" so much, but I think of the arts as heightening people's awareness of what it is to be in the world. The idea of "wide-awakeness" partly comes from Thoreau. "I never met a man who was wide awake," he says. But it's also in phenomenology. Schutz talks about, "Wide-awakeness is the highest plane of consciousness." And then there's Paulo Freire's idea of conscientization.

All those things come together for me as an argument for the arts in education. One of the things that preoccupies me is what kinds of teachers can enhance children's imaginations. The teacher herself has to be alive. The teacher herself can't come in the room with the problem of Hamlet already solved. I think she has to come in with the same open questions, with the same wonder that children will feel.

I prefer Dewey's idea that in education you help children become different, different than they are. There's a transformative element in education, or there should be, and I think having the arts in educa-tion enhances that transformative element; through the arts your experience is enlarged and enhanced—you see more, feel more, un-derstand more.

I have a very good view of Central Park from my apartment win-dows and it's possible that I could get so familiar with that that I never see it, but I refuse that. I keep trying to sort of defamiliarize what I see so that I really see instead of saying, "Oh, it's the same old damn tree, the same old sunset." I have to keep alive to the un-expectedness of what I see out of the windows. That's part of what I think the arts can do.

"Wide-awakeness" can lead to the development of openness

toward difference and a proper sense of humility. It counters one of the worst dangers, and that's indifference and distancing. The opposite, if there is an opposite of wide-awakeness, is indifference—just not looking, not giving a damn. And I worry so much about that because that means blindness to the horrors in the world like Darfur or Congo or poverty here. You look at it and it's so frightening and you'd like to do something and you can't and one of your impulses is to not give a damn. We have to encourage kids to get over that, and the arts help. I see the arts as a counter to indifference and disappointment.

The arts create dialogue. It is dialogue that opens the questions for you and, in the interchange, with somebody else. And the recognition that there are multiple perspectives, many ways of looking at the world, is an accompaniment to honest dialogue. I think, like Dewey and so many others, that human beings freeze if they're autonomous. I was thinking of Dante's *Inferno,* and at the bottom of the inferno are people who are frozen in ice, and the worst thing for Brutus and other great devils is the idea of being frozen. If you can't engage with others, if you only listen to yourself, you are frozen.

Dewey often said that the human being has to be a participant, has to be part of a community in order to be human. One of the big things that we do at Lincoln Center in our workshops—when people are introduced to a medium that they don't know—is provide them with basic ways of moving and experiencing things together. They learn some of the movements and the gestures in, say, flamenco and they move together. Some of them invent their own dances and they create a dialogue that is as important as the learning of the

medium. It becomes a little community and they gather together to try to make sense of flamenco dancing. In that way, art appreciation is linked to ongoing dialogue.

Dialogue is more than just an exchange of opinions, or an argument. I think it involves a kind of opening to one another. It involves a kind of empathy. I remember John Berger saying once that empathy arises out of imagination, and that to be able to have a true dialogue you have to imagine the other's being and you also have to feel a kind of connectedness to her or him.

I also remember Hannah Arendt saying one time, when she talked about dialogue, that when you go home the worst thing you can find is a friend. No, the worst thing you can find is somebody who agrees with you totally; then there can be no dialogue.

I think that dialogue, significant dialogue, doesn't end with a period on the paper. It ends with an open question, with a lot of things unsettled. That's why I do philosophy, because I can't come to any final end to the dialogue, and I hope that's true about teaching. You hope that the students don't leave saying, "Oh, well, now I know, now I have the answers, we've had some good talk." The good talk ought to end with opening and questions.

This reminds me of a comment by Myles Horton, founder of the Highlander Folk School. He was being interviewed by Bill Moyers, and Myles was rocking in a chair, and Moyers asked him, "Who's your favorite poet?" And Myles said, "Percy Bysshe Shelley, because he was a lover of freedom." And when he said that, I thought about how, among other things, Myles left every question open. As committed as he was, and as important an activist as he was, and change

agent, he never knew all the answers, which is one of the things I loved about him.

We need to have regard for and engage with the kids and adults as open systems themselves, and to not impose the canon on them, or determine rigidly what's right, or what's necessary. I think we have to make clear what the culture espouses and what other people care about, but I want the children to choose themselves, to keep open, even as they have regard for tradition.

For example, today, hip-hop and the rest of pop culture make me feel so old, but I have to have regard for that, and what they love. And I ask them to have regard for what I love. There has to be a dialogue between us, and an understanding about what we love in the arts and what nourishes us. I don't want to impose upon them.

Recently I was thinking of an academic who keeps talking about human flourishing. The reason I don't like that is it doesn't involve dialogue; it doesn't involve being with others. A predefined curriculum makes me paranoid because it prevents that exploration and openness of perspective. One of the things about the arts and a lighting up of imagination is that there are so many openings, so many doors open and windows open that you never knew existed because it breaks with a single vision—it opens all kinds of possibilities. There are so many ways, for example, of looking at Hamlet.

A *Hamlet* opened in New York recently and the critics were talking about all the multiple faces of Hamlet. He's funny when he's talking to the players, thoughtful and intelligent at times, and worried and confused at other times. There's no single way to categorize *Hamlet*, or anything that a great artist does.

One of the paintings I talk about a lot is Picasso's *Woman Ironing*, with the sense of the heaviness of the iron and the heaviness of poverty and at the same time the delicacy of her face . . . there are so many alternative possibilities.

I always remember one thing about Chiang Yee, who was a famous Chinese landscape painter. He went to England to paint landscapes, like his Wordsworth landscape. But he painted a Chinese-style landscape, and that's so interesting to me. Or the Nuremberg painters who went to Rome and painted Nuremberg. That's one of the things about art. If you can get past the familiar, you see much more in so many directions. It's like multilinguality.

Perhaps there's a little more hope than there used to be, because teacher-educators are realizing that they are no longer the rulers of the class, that the center of the class has moved from the teacher's desk to some nascent community in the class. There's a little more understanding that you don't unearth meaning, you construct it through an interchange, a transaction between your experience and the experience of what you learn and what people have taught you. In that sense there's some promise for the arts, but if we stay with quantitative assessment and narrow curriculum, we'll go back to the old way of lecturing—"This is what Rembrandt means . . . and this is this and that is that." It's hopeless.

We can't have a predefined curriculum and help children engage with the arts. Children have to be able to choose. There are some kids who choose the visual arts, and others who like to move, and you can't force them into an art form that's not really theirs. One thing is that when you have an artist, a teaching artist, who tries to

translate her or his own creativity into something that people who aren't artists can understand, very often it frees the children to be what they hope to be and not a mere copy of the teacher or a receptacle for the teachers.

John Dewey talks about the aesthetic in ordinary life, like setting a table with cups. I think it's very important for people to realize that culture is in large measure defined by the arts that are part of that culture. And I think that what's called "the social imagination" is so terribly important because it again has to do with imagining alternative realities . . . like today, with all the thievery and all the bad examples, it's terribly important to have children use the social imagination to identify the deficiencies and to try to repair them. You can only repair them if you imagine how things should be and how they might be.

Shirley Brice Heath

Shirley Brice Heath is professor emerita of English and dramatic literature at Stanford University, and a professor at large at Brown University. A linguistic anthropologist, Ms. Brice has studied how different kinds of social and cultural learning environments support children's early and later language development. She centers her research on visual perception, language development, and acquisition of agency as learner. She has worked primarily in settings that include community organizations and learning environments such as museums, arts centers, botanical parks, urban gardens, sports teams, and teen-initiated projects. In her work with schools, her focus has been on creative programs using visual, musical, and dramatic arts.

She is the author of the classic book Ways with Words: Language, Life, and Work in Communities and Classrooms. *Her most recent publications include:* On Ethnography: Approaches to Language and Literacy Research *(with Brian Street); and* Handbook for Literacy Educators: Research in the Visual and Communicative Arts *(vols. 1 and 2).*

Maxine Greene started early in her life to think about the arts and their role in the lives of young learners. She moved through her primary education storing up the imaginative energies and critical skills she later put to work in her university education. She had grown up observing and listening to others talk about art and looking intently and finding different angles from which to take in visual arts. She began asking questions about art and found that answers did not come easily. She sought out meaning in art and concluded that education is about meaning, imagination, and a sense of the self within the wide world of the arts. Her aesthetic philosophy and advocacy of arts learning rest on these premises. She determined that art is for every learner and that the arts need to be with learners throughout their lives regardless of circumstances of birth and life course.

Maxine came to her philosophy of aesthetics through observing deeply her own responses to and with the arts throughout her childhood. Later she did the same by observing children, asking them what they were seeing, and noting the extent to which children felt comfortable within a wide world of art and kept alert to its forms, meanings, and combinations of meanings. Maxine wishes the same for all learners, young and old, including those who seek to instruct and guide others in their learning. She believes firmly in the value to teachers of their being alert to where imaginative approaches can take learning of all kinds—rote, performative, investigative, and exploratory.

For Maxine, learning cannot escape *transformation* as its fundamental nature and purpose. Learning must never rest simply within

the transmissive, in which channeling information and skills from instructor to student is seen as the primary goal. Maxine wants both instructor and student to be, think, and act as sources. Thus the movement of learning is reciprocal, ever changing, self-assessing, open to critique, and ready with imagination. Keeping this conduit actively two-way means that neither distance nor blockage can occur between learners. Humility equates with openness, curiosity with engagement, commitment with connection. Indifference, intolerance, and other negations of knowledge and the knowing process will not develop unless lines of conduction are working both ways.

In the transformative power of learning, what is the role of literature, visual arts, dance, music, film, and all the other arts across cultures? Maxine has maintained in her own life and in the many ways she has promoted arts in the learning lives of others that the arts equate with openness. Art never allows itself to be closed, absolute, or authoritarian. Within the arts, advocates, owners, critics, and promoters may attempt all they wish to make the arts exclusive and dictatorial. But never will there be only one possible rendition of an emotion, a single telling of a plot, or the ultimate onetime performance. There will always be other interpretations, other arts, and renewed insights that inspire new pieces, genres, combinations of art forms, and mixtures of textures, colors, sounds, and movements.

Philosophers, human developmentalists, and cognitive neuroscientists see and feel these effects from participation and immersion within art forms across the life span. Along with other social scientists, I have looked closely at the features of openness in

learning environments that the arts create. Each art form—visual arts, dance, dramatic art, video, film production—builds on these general features while also providing unique cognitive contributions. For example, participation in visual arts positively correlates with academic tenacity and achievement. Studio life in the visual arts provides young artists extensive practice in visual focus on detail, creative work with the hands, grasp of basic physics and mathematics, a sense of identity with the history of the art form, and communication skills needed to explain a work of art.

The ecological features of choral and instrumental music offer different benefits. Here a disparate group comes together around music to be part of a coordinated whole. Attentional focus, self-discipline, group identity, and visual and verbal memory, as well as literacy and numeracy, come with collaborative musical production. Learners who want to become members of a choral or instrumental music ensemble develop habits of sustained attentiveness and observational acuity. They learn to tolerate repetition as vital to effective practice, and they become accustomed to the many ways in which parts contribute to the whole in music.

For young children, it is especially important that they gain practice in simultaneous interpretation of layers of symbol systems—from musical notation to a conductor's hand and eye movements. They come to take as given the fact that patterns of symbolic structures provide the means of measuring sound, space, time, and emotional interpretation of the music. Unique features of these learning environments help explain how novices work from beginning-level ensemble participation toward skills and concepts necessary for

performing in established instrumental music groups from jazz combos to youth orchestras.

Also critically important to young learners who take part in the arts are the opportunities that these environments offer for learning to strategize. Music and dance, perhaps more than any other art forms, require repetitive practice. Both art forms rely on skills and knowledge whose embodiment is driven into the memory of muscles in every part of the body. Young learners in music and dance must habituate the notion that everything they do within their art forms is patterned so as to enable prediction and expectation of what is next. Sequencing of complex overlapping symbolic structures in music and dance exceed in embodiment demands the requirements of other art forms.

All art forms enable in one way or another the motivated practice necessary to instill habits fundamental to linguistic, strategic, interactional, and aesthetic memory. The literary arts, whether nursery rhymes of children's literature, ancient texts of Sanskrit philosophy, or contemporary poetry and fiction, embed within each reader and writer the vital sense of the dialogic. Whether inside one's own head, with a beloved friend, or with an audience of strangers, the back-and-forth of interpretation is the constant companion of the arts. The literary arts assure us that we are not alone in our dilemmas, crises, debates, and life decisions. Art always lets us know that it will never be created or appreciated without inspiring or inciting dialogue.

In the creation of the mammoth tombs that the ancient emperors of China and Egypt forced the craftsmen of the kingdoms to build,

we can imagine that there were no public openings for dialogue or critique. However, we can be sure that among themselves the artisans talked about their work and the facial expressions they chose to render in their carvings. We can imagine also that these "uneducated" artists speculated about the likely folly of the mighty in overlooking the possibility that the greater gods of the afterlife would be offended by the cruel demands made of craftsmen in the earthly world. Empathy feeds imagination, and no one can view either the horses or the horsemen created by "the first emperor of China" without sensing that each artist's hand and eye moved with empathetic imagination. The exhibition of this title, which toured art museums around the world at the end of the first decade of the twenty-first century, lingers in the mind of every viewer not in the story of the "great" emperor. What is remembered instead are the fine details of the nostrils of the horses, the lines of facial expression of each chariot driver, and the hints of individual personalities etched in the bodily stance of every member of the cavalry.

The memory, emotion, knowledge, and physical and mental skills that come through extended participation in the ecology of the arts are central to lifelong learning. Art is central to the craft and science of teaching. Thus every teacher immersed in one or another art form in the course of professional preparation or in choice of avocation is likely to find some way to ensure that arts production and interpretation remain at the heart of learning. The arts evoke feelings and emotions, release of physical and mental tension, and create empathetic identification with human agents as they respond to the twists and turns of fate. Such empathy enables emotional alignment

and inner regulation through discipline and a sense of belonging and connecting. These ideals inspire teachers to look beyond where their students now are to the futures that learners will envision for themselves.

Neuroscientists and social scientists debate the question of whether throughout human history music and the other arts have had any direct biologically adaptive value. That debate is certain to go on. However, in the minds of philosophers, human developmentalists, and educators, the question is not what *the* answer may be, but instead *how many* unfolding ways remain to be discovered about the importance of aesthetic creation, participation, and elaboration throughout the human life span and across human history.

In the art that is so much a part of Maxine's life and that she would have in the life of every learner, there is "might." However, that "might" is part of the verb and not the noun. Maxine sees the action and intention in the "might" that surrounds all the arts. Learners will be strengthened when they pursue that which comes in the open powers of the modal verb of possibility. Staying open to what "might" be seen, heard, interpreted, created, and discovered gives those who love the dialogic of thinking, learning, and conversing the strongest might of human potential in spirit, intellect, and imagination. Of this power of the arts, we can never say too much.

Afterword

ROBERT JACKSON

Robert Jackson, in part inspired by his prolifically talented daughters who grew up in New York City schools, is a local politician who has never flip-flopped on the crucial topic of educational equality. In 1991, Mr. Jackson co-founded the nonprofit Campaign for Fiscal Equity (CFE), bringing together parents and education advocates to file the landmark case CFE v. State of New York. *Today CFE leads the effort to protect and promote the constitutional right to the opportunity for a sound, basic education for all of New York's public school students. Mr. Jackson is a New York City Council member. A native New Yorker who was born and raised in Manhattan, Mr. Jackson attended New York City public schools and later graduated from the State University of New York at New Paltz. Mr. Jackson describes his highest priority as the safety and well being of his constituents.*

My three daughters went to P.S./I.S. 187 on 187th Street and Cabrini Boulevard. They had a recital every spring where they played their little recorders all the time. I was a parent in that school for twenty continuous years. I got used to the little kids playing simple little

songs. Then they get a little older and it sounds a little better. Then you hear the junior high school band playing, and gradually some individuals grow more and more talented, playing other instruments at performances and recitals. I remember all of that very well.

The arts were very important to the school, to the parents' association of which I was a member, and to the community. I remember clearly a teacher in my oldest daughter's junior high school. The school, I.S. 528, is named after that teacher now: the Bea Fuller Rogers School. And who is she? She was the art teacher at P.S./I.S. 187 where my kids went to school. We—when I say "we" I refer to the school board—named the school after her because she was a beloved art teacher in District 6. Besides teaching ceramics, painting, and other arts, she took the kids on trips to the museums and to other cultural institutions.

She was murdered in her home, which was about two or three blocks from the school. It was a devastating blow to her immediate school family, and also to the larger District 6 family. She was a very colorful, dedicated art teacher who expanded the boundaries of what she was paid to do. Art was her life.

Looking at my twenty years as a parent at P.S./I.S. 187, I am proud to have three daughters who have gone through that K–8 program. My oldest daughter, Sadya, is an MD now; my second daughter, Azmahan, is an educator; my youngest daughter, Sumaya, graduated from Juilliard and is now a professional dancer.

The arts were part of the experience of all my children. My wife

and I, as parents, gave our children that gift because we felt it was an invaluable one.

There are children who don't have the opportunity or the occasion to participate in the arts. It is the obligation of schools to provide those occasions for all children. As someone who has been a parent activist since my oldest daughter entered public school in 1980, a member of the school board in District 6 (Washington Heights, Inwood, and Hamilton Heights), and now a representative on the education committee of the New York Council, I see the arts as an integral part of education. We can't simply teach our kids reading, writing, and arithmetic and that's it. Parents don't want that. Parents want a full education for their children.

At P.S. 153, the Adam Clayton Powell Jr. School, which replaced my old elementary school, parents are very pleased about the quality of education. The school is no longer overcrowded as it used to be. People are drawn to that school because, besides being a beautiful building, it contains a dance studio, art classrooms, and a music room. The capital allocation that I secured a few years ago allowed them to build it. Initially, the gym floor was concrete; now it's wood. They have a dance studio with bars and mirrors, and changing rooms for the young dancers. As I toured the building, I was elated to see a student with a violin receiving one-on-one tutoring with a music teacher.

When we talk about what parents want for their children's education, opportunity to participate in the arts is high on the list. Parents

shouldn't be faced with having just one school in the district with strong arts programs, yet this is often the case. Everybody tries to get their children in there, and inevitably many children are turned away. Right now, the arts are drawing people to P.S. 153, but they should be in every school.

Beyond fighting for a quality education for your own child, there is a broader fight going on all of the time. Budgets are getting tighter and tighter, and some people think part of the solution is eliminating the arts, after-school programs, or gym classes. Physical education, art, music, theater—all of these things are just as important as reading, writing, and arithmetic. All people learn differently, and learning through other mediums—sports or the arts, for example— is an important alternative to traditional classroom learning with a teacher at the board and a book in front of you.

So much is lost by not having exposure to the arts in childhood. Some who are central to making educational policy believe in this ideal, but with the demand on making the "grade," and the pressures put on principals and administrators, the arts become a problem. When your employment depends on test results, then your focus is going to be on survival. There is tremendous pressure to ensure high test results that reflect positively on you so that you can keep your job. In this environment, the arts and other untested areas suffer. There is so much emphasis on so-called measurable outcomes, yet there's no exam that gives a numerical grade for how well our kids are doing in arts, theater, music, or dance.

Students suffer from not being exposed to a holistic approach to

their education. They're missing out on culture and on different intelligences produced by a well-rounded education. They suffer from not learning to express themselves through music, through rhythm, through painting, through colors, and through shapes. Being able to express oneself is a basic skill that everyone should be allowed to develop.

Parents should demand the arts for their children, and demand a holistic education for their children overall. If a school is only focusing on reading, writing, and arithmetic, parents should say "This is not enough." Theater is just as important as math, art class is just as important as gym class, and gym class is just as important as sitting and doing math tabulations. This is where the parents' associations play a very important role, where a community school district board plays an important role, or—in New York City for example, at the city level—where the Panel for Educational Policy is key because it impacts citywide policy.

It starts at the top. As a councilman, I would advise my constituents to find out what your school has to offer as far as the arts are concerned, speak about it at your parents' association, and demand that they have more. The arts offer a way to bring the community together with the school, and create a spirit for the school that would be lacking if schools were only about testing.

A good arts program can be a compelling reason for kids to go to school, offering real motivation. Kids are drawn to school by so many things—by a good teacher, by knowing that they're excelling in math or science, or loving it when their art teacher is helping them

on an art project. When painting, drawing, dancing, singing, or acting are central to a young person's experience at school, a different aspect of that child comes out. What you see is natural ability, natural talent, and natural expression. The arts are part of a holistic approach not only to education, but also to life.

A Note to the Reader

Founded in 1949, the Stella Adler Studio of Acting upholds a unique focus in American actor training. Like Jacob P. Adler, Stella Adler and Harold Clurman—whose work inspired and laid the foundation for our efforts today—the studio affirms that the primary function of theater is to uplift humanity. A successful student for Stella is not necessarily one who becomes famous or rich, but one who connects to their deeper self and to our shared humanity. Under the leadership of Artistic Director Tom Oppenheim, the studio has evolved from an acting school to a cultural center determined to train actors and support artists not despite, but in the face of a world in crisis. For over fifteen years Oppenheim has developed programming that aims to support young artists by creating an environment for all students to become actors like Stella and those in the Group Theater: actors who are socially and consciously aware and whose awareness contributes to their ability to act passionately.

The Outreach Division at the Stella Adler Studio of Acting serves low-income teens and/or those who do not have arts programming at school. Outreach provides free theater training to urban youth,

focusing on those who live under the poverty level. The New York City Council Committee on Education has reported that despite efforts, a quality arts education has remained elusive for many NYC schoolchildren. According to the NYC Department of Education, fewer than one in five NYC public high schools has a theater teacher. Of those teachers, most are not trained artists but academics who themselves did not receive a comprehensive arts education. Adler Outreach addresses these iniquities by providing high-level, long-term training to disadvantaged students exclusively from trained theater professionals and practitioners.

For more information on the Stella Adler Studio's Outreach Division, please contact us at:

The Stella Adler Studio of Acting
31 West 27th Street, Third Floor
New York, NY 10001
www.stellaadler.com
www.facebook.com/stellaadler
www.twitter.com/stellaadlerny

Other Education Titles Available from The New Press

Be Honest: And Other Advice from Students Across the Country
Edited by Nínive Calegari
From 826 National

826 National co-founder and former CEO Nínive Calegari presents a riveting book full of surprising insights from young people who have a lot to say to their teachers.

Beyond the Bake Sale: The Essential Guide to Family-School Partnerships
Anne T. Henderson, Karen L. Mapp, Vivian R. Johnson, and Don Davies

A practical, hands-on primer for helping schools and families work better together to improve children's education.

Black Teachers on Teaching
Michele Foster

An honest and compelling account of the politics and philosophies involved in the education of black children during the last fifty years.

Michele Foster talks to those who were the first to teach in desegregated southern schools and to others who taught in large urban districts, such as Boston, Los Angeles, and Philadelphia. All go on record about the losses and gains accompanying desegregation, the inspirations and rewards of teaching, and the challenges and solutions they see in the coming years.

The Case for Make Believe: Saving Play in a Commercialized World
Susan Linn

A clarion call for rescuing creative play from the grips of commercialism.

City Kids, City Schools: More Reports from the Front Row
Edited by William Ayers, Gloria Ladson-Billings, Gregory Michie, and Pedro A. Noguera

A contemporary companion to *City Kids, City Teachers,* this new and timely collection has been compiled by four of the country's most prominent urban educators. Contributors including Sandra Cisneros, Jonathan Kozol, Sapphire, and Patricia J. Williams provide some of the best writing on life in city schools and neighborhoods.

City Kids, City Teachers: Reports from the Front Row
Edited by William Ayers and Patricia Ford

Reissued with a new introduction by William Ayers that reflects on how improving urban education is more essential than ever, this book has become a touchstone for urban educators, exploding the stereotypes of teaching in the city. In more than twenty-five provocative selections, set in context by Ayers and Ford, an all-star cast of educators and writers explores the surprising realities of city classrooms from kindergarten through high school.

Classroom Conversations: A Collection of Classics for Parents and Teachers
Edited by Alexandra Miletta and Maureen Miletta

An outstanding collection of classic readings on teaching and learning from Dewey to Delpit—the age-old ritual of the parent-teacher conference will never be the same again.

Crossing the Tracks: How "Untracking" Can Save America's Schools
Anne Wheelock

A highly praised study of ways in which schools have experimented with heterogeneous groupings in the classroom.

Diary of a Harlem Schoolteacher
Jim Haskins
Classics in Progressive Education series, edited by Herbert Kohl

This classic work, which had been long out of print, recounts the experiences of an African American teacher during his first year working in a Harlem elementary school in the 1960s.

The Discipline of Hope: Learning from a Lifetime of Teaching
Herbert Kohl

The first paperback edition of the master educator's insights from four decades in the classroom.

Dismantling Desegregation: The Quiet Reversal
of Brown v. Board of Education
Gary Orfield and Susan E. Eaton

Dismantling Desegregation explains the consequences of resegregation and offers a more constructive path toward an equitable future. By citing case studies of ten school districts across the country, Orfield and Eaton uncover the demise of what many feel have been the only legally enforceable routes of access and opportunity for millions of school children in America.

Everyday Antiracism: Getting Real About Race in School
Edited by Mica Pollock

Leading experts offer concrete and realistic strategies for dealing with race in schools in a groundbreaking book offering invaluable and effective advice.

Fires in the Bathroom: Advice for Teachers from High School Students
Kathleen Cushman

Kathleen Cushman's groundbreaking book offers original insights into teaching teenagers in today's hard-pressed urban high schools from the point of view of the students themselves. It speaks to both new and established teachers, giving them firsthand information about who their students are and what they need to succeed.

Fires in the Middle School Bathroom:
Advice for Teachers from Middle School Students
Kathleen Cushman and Laura Rogers

This invaluable resource provides a unique window into how middle school students think, feel, and learn, bringing their needs to the forefront of the conversation about education.

Fuller's Earth: A Day with Buckminster Fuller and the Kids
Richard J. Brenneman
Classics in Progressive Education series, edited by Herbert Kohl

Toward the end of his life, the visionary American philosopher, inventor, architect, mathematician, and poet Buckminster Fuller was asked to explain to a group of children his vision of how the universe works. The book that resulted from this encounter is not only the most straightforward exposition available of Bucky's radical worldview but also perhaps the most lovable and personal portrait ever produced of the man who has been called "the planet's friendly genius."

Going Public: Schooling for a Diverse Democracy
Judith Renyi

A historically informed overview of the multicultural education debate from a leading advocate.

The Herb Kohl Reader: Awakening the Heart of Teaching
Herbert Kohl

The best writing from a lifetime in the trenches and at the typewriter, from the renowned and much-beloved Guggenheim fellow and National Book Award–winning educator.

How Kindergarten Came to America: Friedrich Froebel's Radical Vision of Early Childhood Education
Bertha von Marenholtz-Bulow
Classics in Progressive Education series, edited by Herbert Kohl

Originally published as *Reminiscences of Friedrich Froebel,* this enchanting 1894 account of the German inventor of kindergartens was instrumental in bringing kindergartens to the United States.

"I Won't Learn from You": And Other Thoughts
on Creative Maladjustment
Herbert Kohl

Herb Kohl's now-classic essay on "not learning," or refusing to learn, along with four other landmark essays.

Justice Talking: School Vouchers
Leading Advocates Debate Today's Most Controversial Issues
Kathryn Kolbert and Zak Mettger

In a fascinating overview of the roiling school vouchers controversy, Barry Lynn of Americans United for Separation of Church and State and Clint Bolick of the Institute for Justice debate the merits of school vouchers.

Kindergarten: A Teacher, Her Students, and a Year of Learning
Julie Diamond

Written for parents and teachers alike, *Kindergarten* offers a rare glimpse into what's really going on behind the apparent chaos of a busy kindergarten classroom, sharing much-needed insights into how our children can have the best possible early school experiences.

Lies My Teacher Told Me: Everything Your American History
Textbook Got Wrong
James W. Loewen

Beginning with pre-Columbian history and ranging over characters and events as diverse as Reconstruction, Helen Keller, the first Thanksgiving, and the My Lai massacre, Loewen offers an eye-opening critique of existing textbooks, and a wonderful retelling of American history as it should—and could—be taught to American students.

Lies My Teacher Told Me About Christopher Columbus:
What Your History Books Got Wrong
James W. Loewen

The bestselling author of *Lies My Teacher Told Me* offers a graphic corrective to the Columbus story told in so many American classrooms.

The Lost Soul of Higher Education: Corporatization, the Assault on
Academic Freedom, and the End of the American University
Ellen Schrecker

A sharp riposte to the conservative critics of the academy by the leading historian of the McCarthy-era witch hunts, *The Lost Soul of Higher Education* reveals a system in peril—and with it the vital role of higher education in our democracy.

Made in America: Immigrant Students in Our Public Schools
Laurie Olsen

Made in America describes Madison High, a prototypical public high school, where more than 20 percent of students were born in another country and more than a third speak limited English or come from homes in which English is not spoken. Through interviews with teachers, administrators, students, and parents, Olsen explores such issues as the complexities of bilingual education and the difficulties of dating for students already promised in marriage at birth.

"Multiplication Is for White People": Raising Expectations for Other
People's Children
Lisa Delpit

From the MacArthur Award–winning education reformer and the author of the bestselling classic *Other People's Children,* a long-awaited

new book on how to fix the persistent black–white achievement gap in America's public schools.

The New Press Education Reader: Leading Educators Speak Out
Edited by Ellen Gordon Reeves

The New Press Education Reader brings together the work of progressive writers and educators—among them Lisa Delpit, Herbert Kohl, William Ayers, and Maxine Greene—to discuss the most pressing and challenging issues now facing us, including schools and social justice, equity issues, tracking and testing, combating racism and homophobia, closing the achievement gap, children in poverty, faculty retention and recruitment, multicultural and bilingual education, rethinking history, and the effects of consumerism on children.

Other People's Children: Cultural Conflict in the Classroom
Lisa Delpit

Winner of an American Educational Studies Association Critics' Choice Award and *Choice Magazine*'s Outstanding Academic Book Award and voted one of *Teacher Magazine*'s "great books," *Other People's Children* develops ideas about ways teachers can be better "cultural transmitters" in the classroom, where prejudice, stereotypes, and cultural assumptions breed ineffective education.

Out of the Classroom and into the World: Learning from
Field Trips, Educating from Experience, and Unlocking
the Potential of Our Students and Teachers
Salvatore Vascellaro

An accessible new resource for educators everywhere that eloquently makes the case for letting children and teachers out of the classroom to open their minds to learning.

The Public School and the Private Vision: A Search for America in Education and Literature
Maxine Greene
Classics in Progressive Education series, edited by Herbert Kohl

In *The Public School and the Private Vision,* first published in 1965 but out of print for many years, Greene traces the complex interplay of literature and public education from the 1830s to the 1960s—and now, in a new preface, to the present.

Rethinking Schools: An Agenda for Change
Edited by David Levine, Robert Lowe, Robert Peterson, and Andrita Tenorio

Rethinking Schools includes sections on rethinking language arts and social studies curricula, testing and tracking, national education policy, antibias and multicultural education, and building school communities. These articles are practical essays by classroom teachers as well as educators such as Henry Louis Gates Jr., Bill Bigelow, Lisa Delpit, and Howard Zinn.

A Schoolmaster of the Great City: A Progressive Educator's Pioneering Vision for Urban Schools
Angelo Patri
Classics in Progressive Education series, edited by Herbert Kohl

Long out of print, *A Schoolmaster of the Great City* illustrates Patri's commitment as a longtime New York public school principal to integrating all backgrounds into the classroom and to nurturing a community that extends beyond the school yard.

She Would Not Be Moved: How We Tell the Story of Rosa Parks and the Montgomery Bus Boycott
Herbert Kohl

The prizewinning educator's brilliant and timely meditation on the misleading ways in which we teach the story of Rosa Parks.

Should We Burn Babar? Essays on Children's Literature and the Power of Stories
Herbert Kohl

Beginning with the title essay on Babar the elephant—"just one of a fine series of inquiries into the power children's books have to shape cultural attitudes," according to *Elliott Bay Booknotes*—the book includes essays on Pinocchio, the history of progressive education, and a call for the writing of more radical children's literature

The Skin That We Speak: Thoughts on Language and Culture in the Classroom
Edited by Lisa Delpit and Joanne Kilgour Dowdy

The author of *Other People's Children* joins with other experts to examine the relationship between language and power in the classroom.

Stupidity and Tears: Teaching and Learning in Troubled Times
Herbert Kohl

A call to arms against the increasingly hostile climate of public education. Among the topics explored by Kohl are the pressures of standards-based assessments and harrowing sink-or-swim policies, the pain teachers feel when asked to teach against their pedagogical conscience, the development of a capacity to sense how students perceive

the world, and the importance of hope and creativity in strengthening the social imagination of students and teachers.

Teachers Have It Easy: The Big Sacrifices and Small Salaries of America's Teachers
Daniel Moulthrop, Nínive Calegari, and Dave Eggers

With a look at the problems of recruitment and retention, the myths of short workdays and endless summer vacations, the realities of the workweek, and shocking examples of how society views America's teachers, *Teachers Have It Easy*—the basis of the documentary *American Teacher*—explores the best ways to improve public education and transform our schools.

Teaching for Social Justice: A Democracy and Education Reader
Edited by William Ayers, Jean Ann Hunt, and Therese Quinn

A popular handbook on teaching social justice for parents and educators, featuring a unique mix of hands-on, historical, and inspirational writings. Topics covered include education through social action, writing and community building, and adult literacy.

Why School? Reclaiming Education for All of Us
Mike Rose

A powerful and timely exploration of this country's education goals, and how they are put into practice, by the award-winning author and educator.

Zero Tolerance: Resisting the Drive for Punishment in Our Schools
Edited by William Ayers, Bernardine Dohrn, and Rick Ayers

Zero Tolerance assembles prominent educators and intellectuals, including the Rev. Jesse L. Jackson Sr., Michelle Fine, and Patricia J.

Williams, along with teachers, students, and community activists, to show that the vast majority of students expelled from schools under new disciplinary measures are sent home for nonviolent violations; that the rush to judge and punish disproportionately affects black and Latino children; and that the new disciplinary ethos is eroding constitutional protections of privacy, free speech, and due process.